For Mothers Day
1998
Love Rachael.

G000152123

THE
Archive Photographs
SERIES

GOSPORT

THE
Archive Photographs
SERIES

GOSPORT

Compiled by
Ian Edelman

CHALFORD

First published 1995
Copyright © Ian Edelman, 1995

The Chalford Publishing Company
St Mary's Mill, Chalford,
Stroud, Gloucestershire, GL6 8NX

ISBN 0 7524 0300 1

Typesetting and origination by
The Chalford Publishing Company
Printed in Great Britain by
Redwood Books, Trowbridge

To Jacqueline

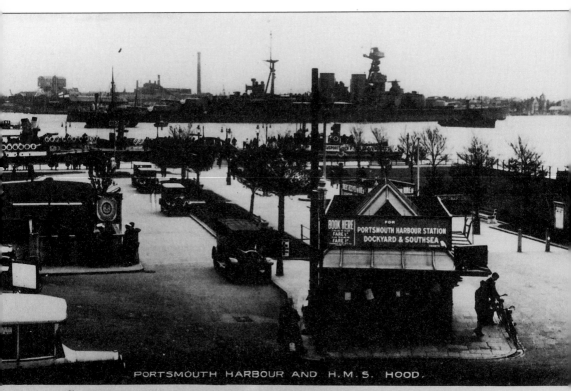

PORTSMOUTH HARBOUR AND H.M.S. HOOD.

Showing entrance to Harbour where ferry and floating bridge plies between Portsmouth and Gosport. In the distance is the City of Portsmouth, at left is the jetty in the Dockyard where large Battleships berth.

Contents

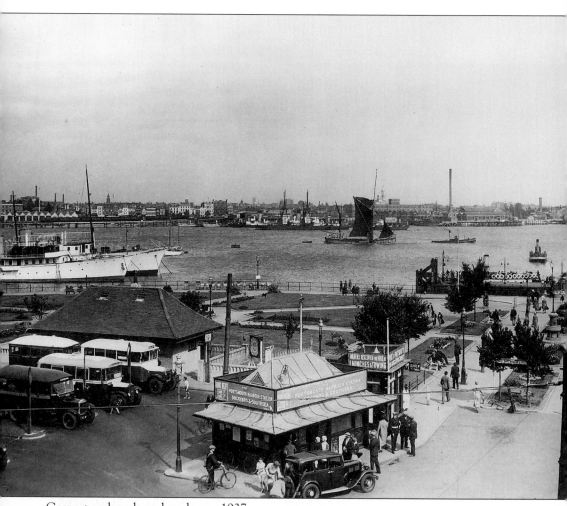

Gosport esplanade and gardens *c.* 1937.

Introduction

Photographers have been taking pictures in and around the town of Gosport since the 1870s. This has provided us with a wealth of pictorial evidence of the Borough. There is, without doubt, no better way of seeing the people and places of the recent past than in a photograph. We are fortunate that when anything happened in the Borough there always seemed to be a photographer there to record it.

The best photographs from the later part of the last century and the early years of the twentieth century have already been published in a previous book by this author. This new book will, therefore, concentrate on photographs dating from the 1920s through until about 1970. The majority of the photographs in this book are unpublished although a small number have appeared previously in local history journals and other publications. The high quality of print production in this book has provided a far better medium in which to view these photographs and so they are reproduced again. Some topics have already been widely reproduced elsewhere i.e. much of Gosport's wartime activities, particularly those associated with the Home Guard and D Day. These topics have, therefore, been largely omitted from this publication.

During the fifty or so years that this book encompasses, there have been dramatic and far reaching changes in the urban landscape of Gosport. There are still buildings to be found in the town centre dating back to the eighteenth century, and whilst some of the familiar landmarks of the past remain, the Borough has almost altered beyond recognition.

This transformation began as a gradual process, as old buildings deteriorated and were considered too expensive to repair or unworthy of preservation. It happened rather more quickly during the Second World War when the Luftwaffe bombed the south coast of England inflicting heavy damage on the Borough. Many of those old buildings that had survived the ravages of time and the wartime bombing of the 1940s eventually succumbed to later town planning policy. The pace of change accelerated after the War with the redevelopment of the town centre. Throughout the twentieth century the small villages in and around the Borough have progressively been embraced by urban expansion as many acres of formerly open land have become housing estates to provide homes for the ever growing local population.

The photographs in this book recall many of the changes, both large and small, that have occurred. Street names such as Seahorse Street or Clarence Square have vanished from the map. Although the railway no longer runs to the town, the fine old station building is preserved and the former railway lines have become cycleways. Trams have been replaced by buses, the

floating bridge used to regularly take vehicles across the harbour, now the only way by car to Portsmouth is by congested road, and diesel power has replaced steam for the cross harbour ferries. Whilst the military still play a dominant role in the economy and land use of Gosport as they have for several centuries, naval armaments have ceased to be manufactured and stored at Priddy's Hard, HMS *Victory* is no longer anchored by the Gosport shore and former barracks echo to the sound of students' voices, not soldiers' or sailors'. These and many other changes have played a part in shaping the character of the Borough.

The process of social and economic change and urban transformation continues to the present day. With hindsight it is easy to criticise the wholesale loss and destruction of the historic townscape of Gosport during the 1950s and 1960s, however a more enlightened view of the value of preserving the local heritage now prevails, and with it the need to protect and appreciate the remaining historic features of the Borough. Hopefully the best of the old will be saved and integrated into the contemporary urban landscape.

The 1920s are now a lifetime ago, the 1960s a complete generation. The images that follow allow us to revisit the Gosport of yesterday. They provide an intimate glimpse of the past, of the buildings, the events that have taken place and particularly of the people who lived and worked in the town. For many people this will be nostalgic journey, as the scenes in the photographs become reminders of the people and places of their younger days. For others too young to remember when Rowner and Bridgemary were still surrounded by open fields, the none too distant past of their parents and grandparents will be brought to life. The photographs in this book remind us of the time before many of the changes in Gosport took place.

Each photograph in this book has been chosen to show different aspects of the life of Gosport during the twentieth century. It is very likely that many unsuspecting readers will find pictures of their friends, relatives or even themselves reproduced in these pages. Every picture in this book has its own story to tell, and I hope that the past will come alive for you in the following pages.

Ian Edelman 1995

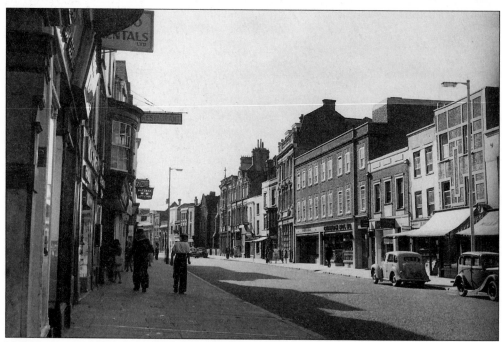

High Street *c.* 1965.

8

One

By the Harbour

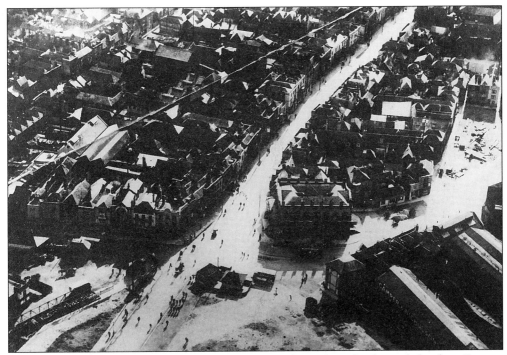

Until the early 1920s, passengers crossing Portsmouth Harbour by ferry alighted at Gosport Hard, seen in the foreground. The High Street is the road running diagonally across this unique view of Gosport from the air in 1924. Some of the shoreline has already been reclaimed with the construction of the sea wall in preparation for the building of the Esplanade and Ferry Gardens. Camper and Nicholson's boat sheds are clearly marked on the lower right.

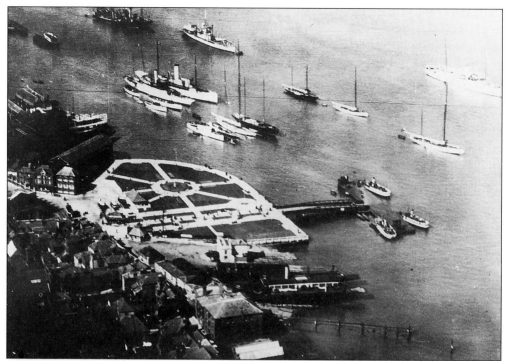

Aerial view of the Esplanade Gardens *c.* 1924. The construction of the Esplanade provided a large and welcoming entrance to Gosport from the harbour. A short jetty led to the floating pontoon where the ferries moored, allowing passengers to embark and disembark en route to and from Portsmouth.

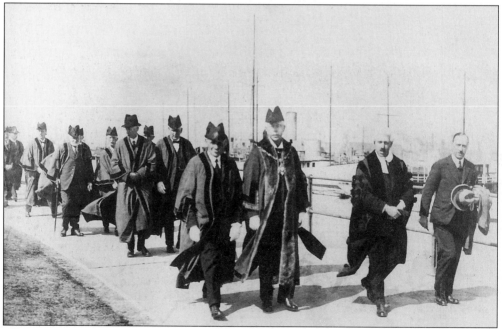

The civic opening of the Esplanade 1924. The Mayor Councillor, H.C. Masterman, councillors and the Town Clerk walk in procession for the formal opening.

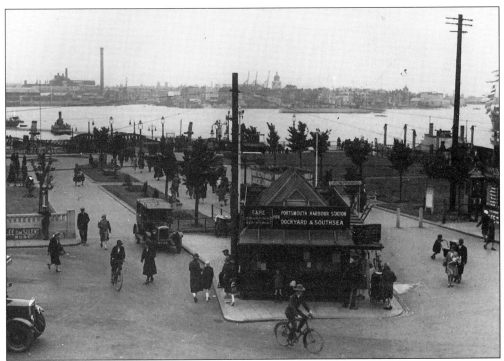

The Esplanade and Gardens *c.* 1930. This is probably one of the most photographed parts of Gosport and has appeared on numerous postcards. It was always bustling with people, whilst in the background the harbour provided an ever changing spectacle, with vessels of all shapes and sizes coming and going. The taxi rank stood to the left of the ticket office.

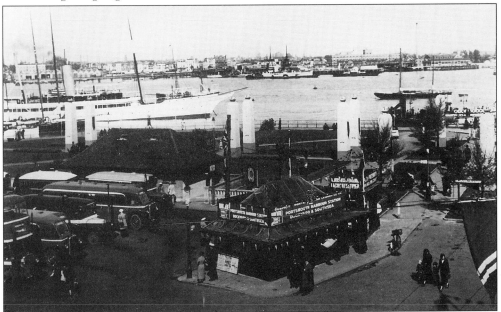

The Esplanade, later known as Ferry Gardens, and now Falkland Gardens, was the terminus for many bus routes making it one of the busiest parts of the town. Here in the mid 1930s, a variety of buses, both old and new, await to take passengers to all parts of Gosport and beyond.

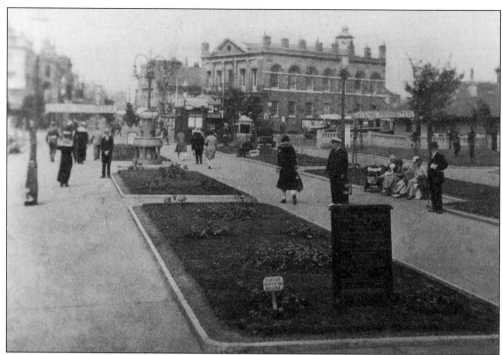

The Esplanade *c.* 1930. It was only a short walk from the ferry pontoon to the High Street (straight ahead) and Beach Street (to the left). The ornamental fountain which was halfway along the path has more recently been relocated at the end of the High Street. The photographer (below) appears to have managed to have caught the small white dog in the act of wetting the lamp-post in this view of about 1930.

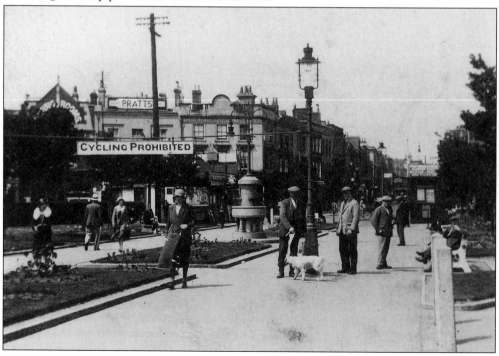

Two
Along the High Street

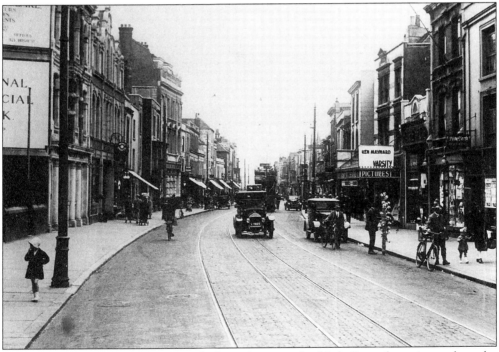

The High Street looking east *c*. 1930. Over the years the High Street has witnessed regular changes. Shops, public houses and buildings have come and gone. There were very few cars at this time and the old tramlines (and a tram) are still clearly visible running along the middle of the road.

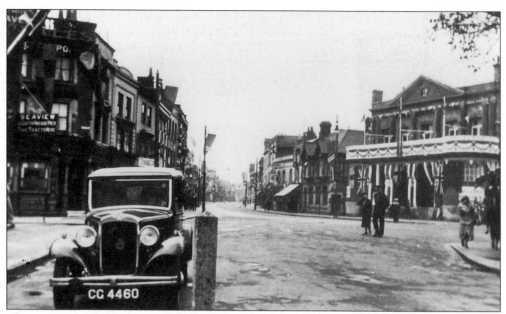

The end of the High Street *c.* 1930. On south side of the street was the Isle of Wight Hoy Tavern and on the north side the Old Market House.

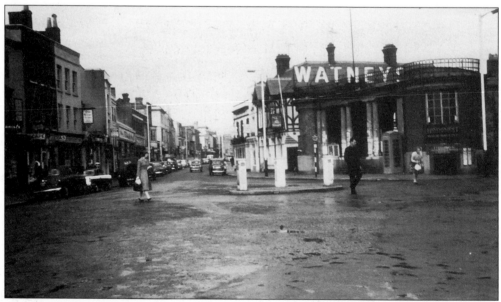

A similar view to that above taken some thirty years later. During the Second World War, the Old Market House received direct hits by incendiary bombs leaving only the burnt out shell remaining. The building was finally demolished in the 1960s. The rather large advertising sign on the side of the Northumberland Arms provides a somewhat discordant addition to the scene.

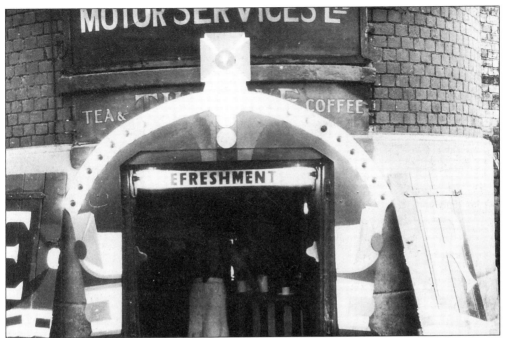

The Dive Cafe c. 1953. The Dive was in the cellars of the Old Market House at the end of the High Street. The Dive moved from the Market Hall in the end of the 1950s when the Old Market House was finally demolished.

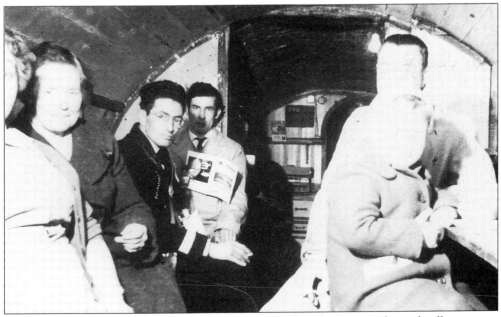

Inside the Dive c. 1953. Many Gosport people remember the Dive with much affection as a popular meeting place.

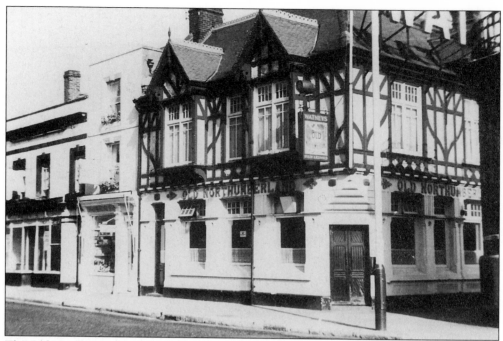

The Old Northumberland, High Street, c. 1960. A tavern has been on this site since the end of the eighteenth century and probably much longer. Next door to the Old Northumberland (left) was the Gosport Photographic Service and Paley's Restaurant.

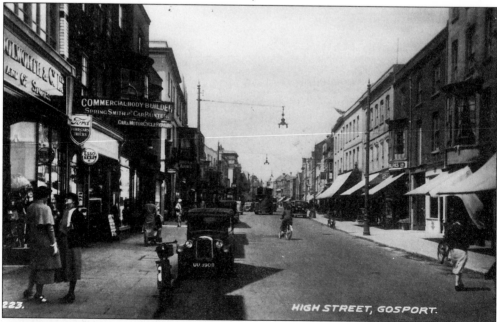

High Street looking west c. 1936. The old tramlines which ran up the centre of the street are now gone. The electric street lighting can be seen suspended across the road. Woolworth's is newly arrived in the High Street and has remained on the same site since, although the fine old shop front has gone. Clarence Cory's garage is next door and the India Arms can be seen further down on the same side of the street.

16

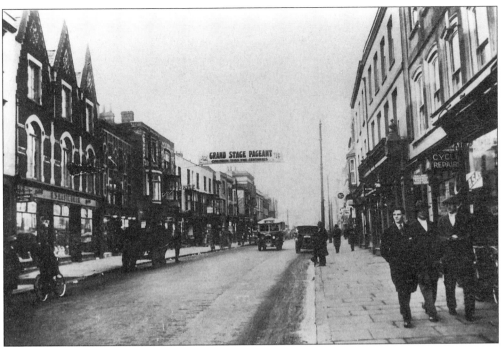

The High Street looking west *c.* 1936. On the north side of the High Street (left) is Masterman and Sons, gents outfitters, and opposite Clarence Cory's bicycle business.

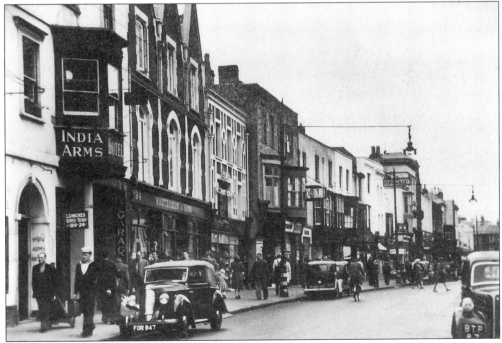

High Street looking west in the early 1950s. A similar view to above but some years later.

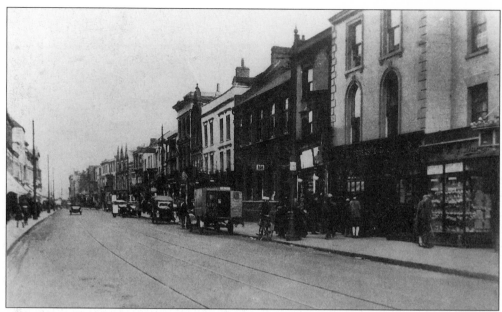

High Street *c.* 1928. The canopy of the Gosport Theatre appears to the right of the picture, next door is Dukes tobacconist, and then at 116 High Street George Peters Wine, Beers and Spirits Merchant.

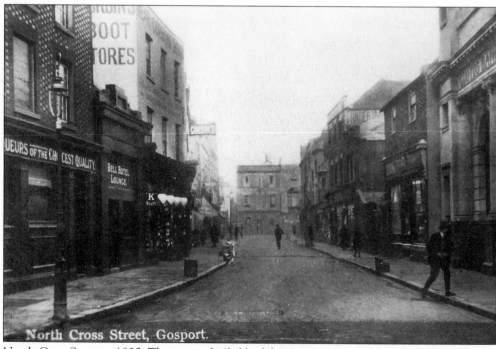

North Cross Street *c.* 1925. The west side (left) of the street was completely demolished in the 1970s, followed by most of the buildings of North Street (at the far end). The buildings on the east side (right) remain substantially unaltered at first floor level and above.

4 High Street *c*. 1935. This was the head office of the Gosport Waterworks Company. The gentleman by the door is Mr Cobbett, the Chief Clerk. Today, the building has changed very little, although the railings were probably removed during the Second World War for salvage, and a single bay window has been inserted in the ground floor frontage in place of the fine original sash windows which were etched with the Water Company's name.

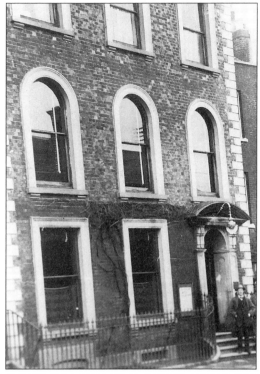

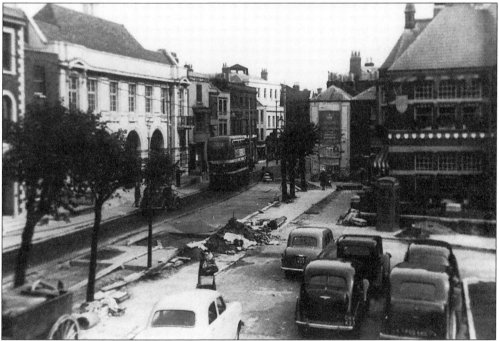

The High Street looking east from the Conservative Club 1953. With the exception of the building on the very left (the former Waterworks office – see above), all the other buildings in this photograph have since been demolished and replaced by somewhat characterless modern structures!

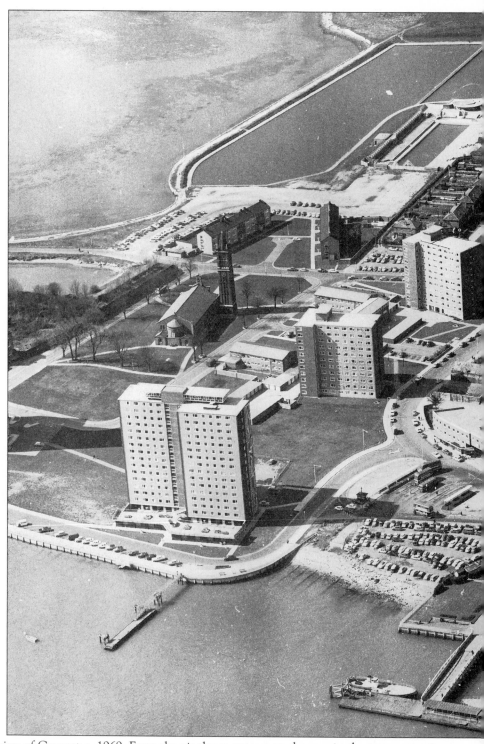

Aerial view of Gosport *c*. 1969. From the air the more recent changes in the townscape since this photograph was taken can be seen. The bus station has been built and the Esplanade

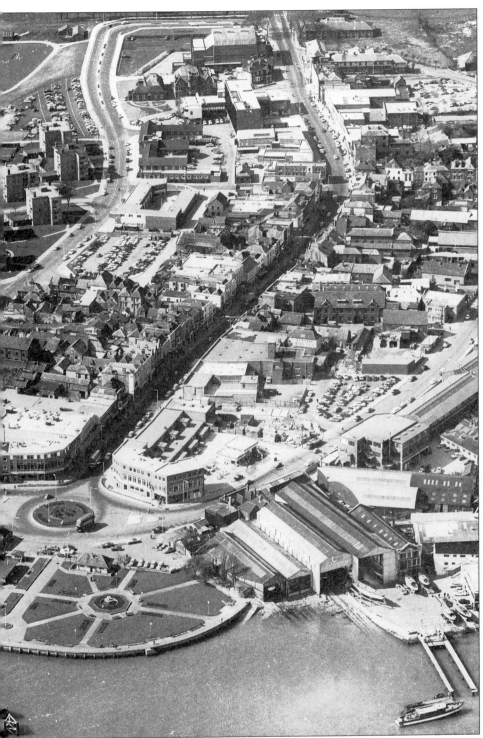

lengthened. The new ferry ticket office has already replaced the old one. The Gosport
swimming pool (upper centre left) has since been backfilled and the south relief road has been
constructed. Many of the old buildings have been demolished and new ones built in their place.

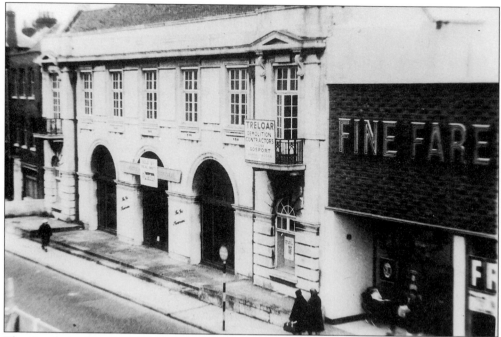

The Southern Gas Board showrooms, 5 High Street (formerly the Gosport Gas Company's offices and showroom) just prior to its demolition. This interesting building of Portland stone was yet another casualty of 1960s redevelopment.

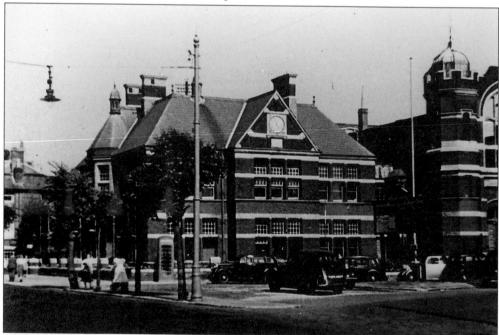

Gosport Town Hall 1950. It was built in 1885 next to the Thorngate Hall (right). At this time the Gosport & Alverstoke Urban District Council had fewer responsibilities than a local authority today, and as the work of local government increased the council outgrew the old building. It was finally replaced by the present building which opened in 1964.

Three
Trains and Boats
and Planes

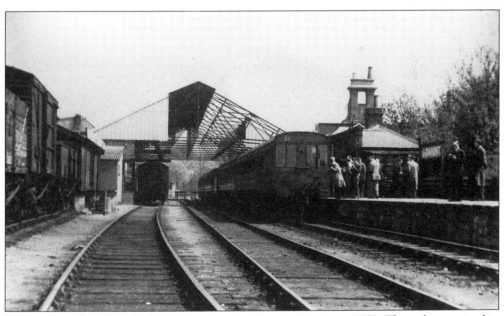

Passengers ready to board a 'special working' at Gosport Station *c.* 1950. The railway arrived in Gosport in 1842 as a branch line of the London and South Western Railway. Passenger services from Gosport finally ended in 1953, although the line was used for goods traffic until 1969.

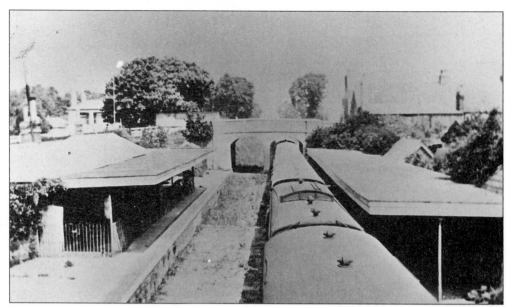

Gosport Road Station looking north towards Bury Arch (now the site of the telephone exchange) c. 1930. This station was on the Stokes Bay Line opened in 1863 and in operation until 1915. The line ran to the Stokes Bay pier where passengers could embark on a ferry to the Isle of Wight.

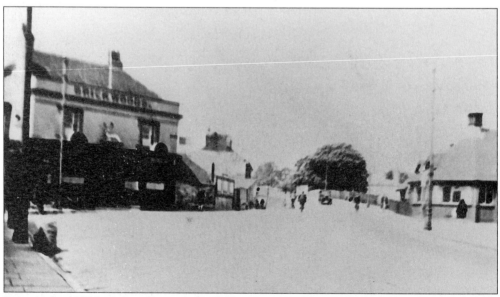

Bury Arch c. 1930, took traffic over the Stokes Bay Line from Stoke Road into Bury Road. On the left is the old White Hart public house, since completely rebuilt.

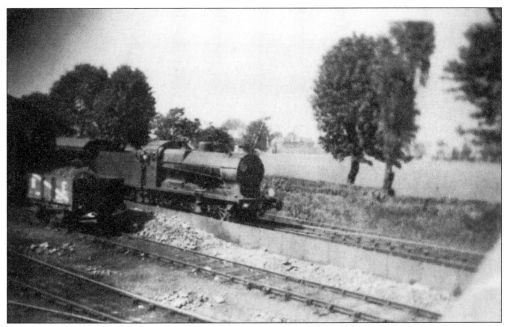

A steam locomotive passing the old engine sheds and St Vincent Fields at Gosport Junction *c.* 1937. Railway enthusiasts will be pleased to know that the locomotive is Q class No. 534.

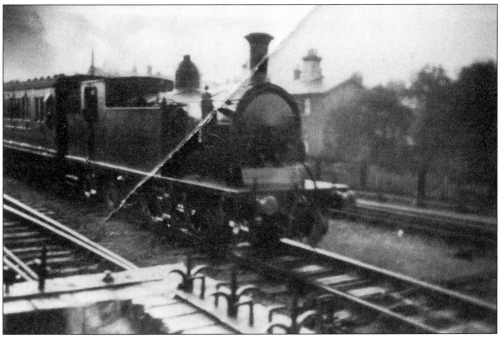

Steam locomotive No. 109 at Gosport Junction *c.* 1937.

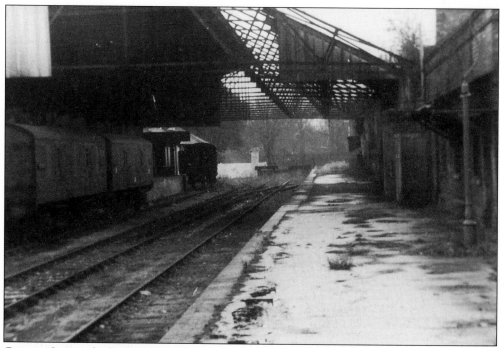

Gosport Station looking towards Spring Garden Lane *c.* 1968 (above). The station now lies derelict and since this photograph was taken, the entire roof has been dismantled and the lines have been removed. At the other end of the platform (below) a small estate of new houses has been built over the former track. The original colonnaded station structure remains and is a particularly fine piece of Victorian railway architecture.

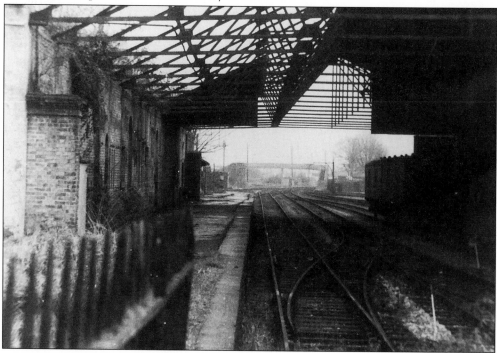

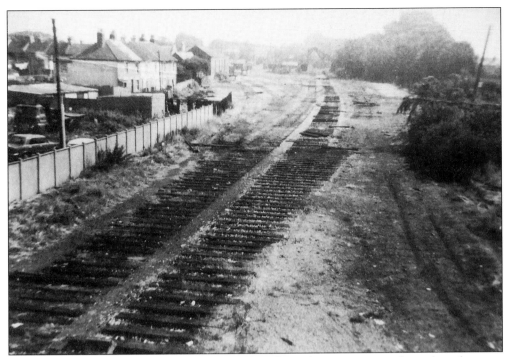

The track seen from the footbridge which allowed people to cross over the railway between Queens Road with Albert Road, with Gosport Station in the background, late 1960s. The lines have been removed, although the wooden sleepers are still in place.

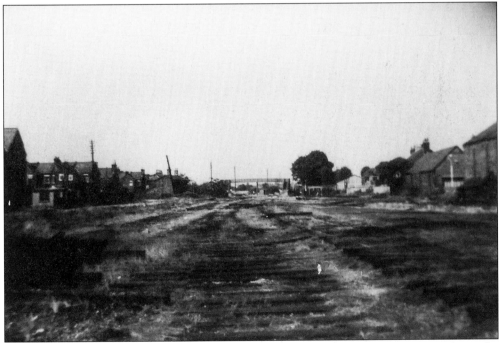

Looking east towards the same footbridge late 1960s. Since the demise of the railway, the former route has been used as a cycleway.

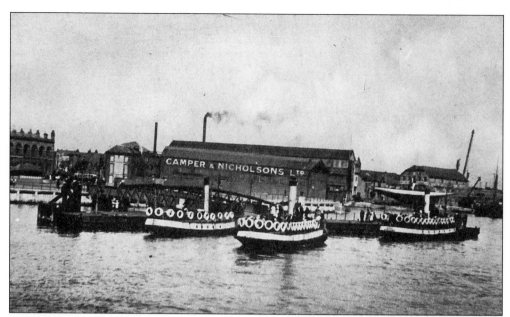

Steam ferries at the Gosport Pontoon *c.* 1935. Boats are probably the oldest mode of transport in Gosport. In the early days, the watermen transported goods and people across the harbour in their small boats. Later it was the steam ferries which plied the route between Gosport and Portsmouth carrying many hundreds of passengers every day. In the background, the Camper and Nicholson boats sheds dominate this part of the harbour.

Passengers arriving at the Gosport Ferry Pontoon *c.* 1950. These ferries were capable of carrying 300 passengers and their bicycles for the six minute crossing of the harbour to Portsmouth Hard.

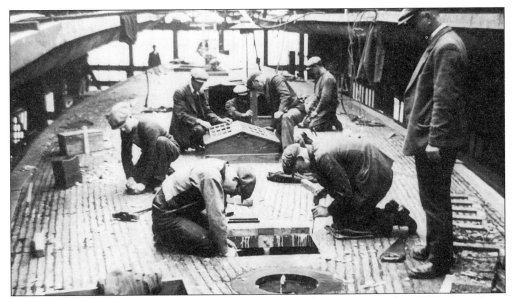

Caulking the deck of a J Class yacht at Camper and Nicholson Boatyard *c.* 1930. Boats have been built in the town for many hundreds of years. All of Gosport's finest and most renowned vessels were built at the yard of Camper and Nicholson. They were one of the main employers in the Borough, building a diversity of vessels, including racing yachts, ferries, a variety of pleasure craft.

Beach Street *c.* 1930. Many large yachts were 'slipped' during winter months – that is pulled out of the water, at which time any repairs and maintenance, particularly below the waterline, could be carried out. The bows of these yachts overhung Beach Street from Camper and Nicholson's slipways.

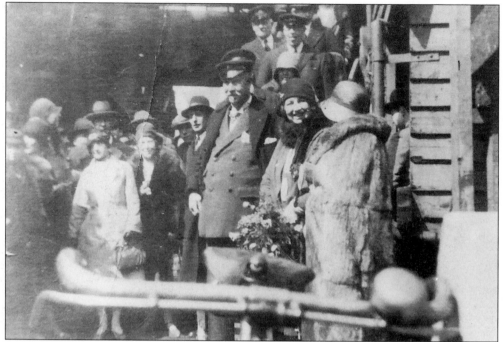

Sir Thomas Lipton, the millionaire grocer, accompanied by Lady Salisbury at the launch of his America Cup challenger yacht *Shamrock V* at the yard of Camper and Nicholson in 1930.

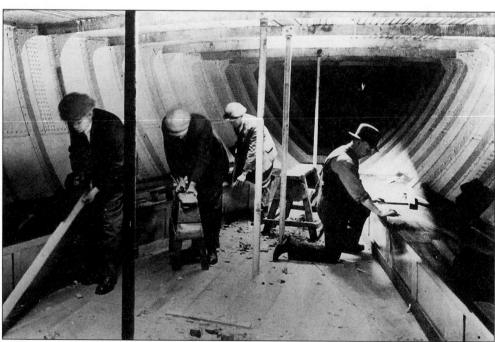

Skilled craftsmen at work inside the J Class racing yacht *Endeavour*, being built for T.O.M. Sopwith *c.* 1933.

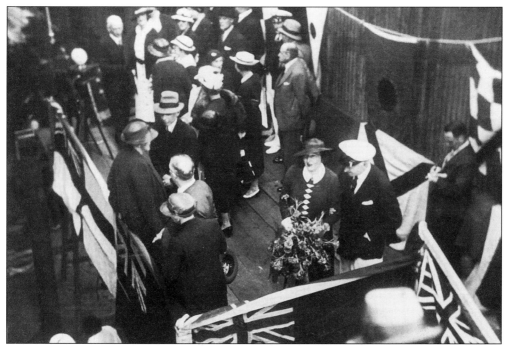

Sir T.O.M. and Lady Sopwith and guests on Camper and Nicholson's launch platform for the launch of the J Class yacht *Endeavour* April 1934.

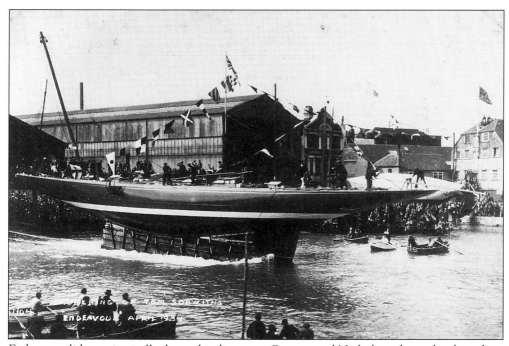

Endeavour slides majestically down the slipway at Camper and Nicholson during her launch in April 1934. On the far right of this photograph, is the Ratsay and Lapthorn sail-loft where her sails were made.

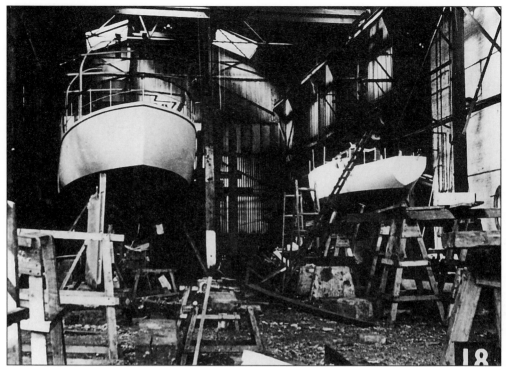

Inside No. 1 shed at Camper and Nicholson's Boatyard 1950. The vessel on the left is the *Esmerelda* built before the Second World War, but later refitted for naval work to be used for detecting acoustic and magnetic mines. In this photograph, she is being refitted again following her decommission. The smaller yacht was the *Phoenix II*, a prototype racing cruiser.

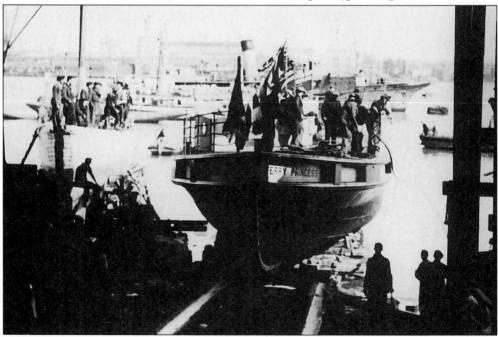

The launch of the *Ferry Princess* from the slipway of No. 1 shed 1950.

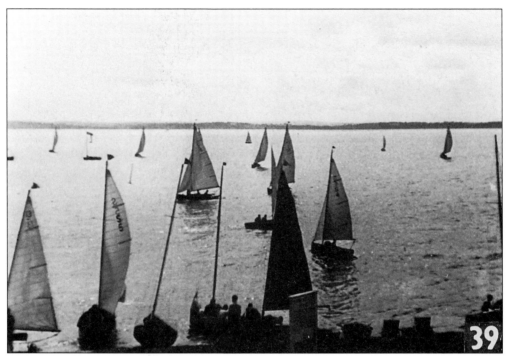

Regatta Day at the Stokes Bay Sailing Club in August 1950. The Solent has for many years been a popular venue for both recreational and competitive sailing.

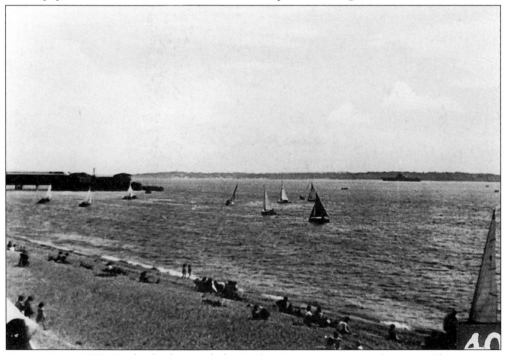

Regatta Day 1950. In the background the Stokes Bay pier can just be seen. The pier was originally used for ferries to the Isle of Wight. Later it was taken over by the Admiralty but was finally demolished in the 1970s.

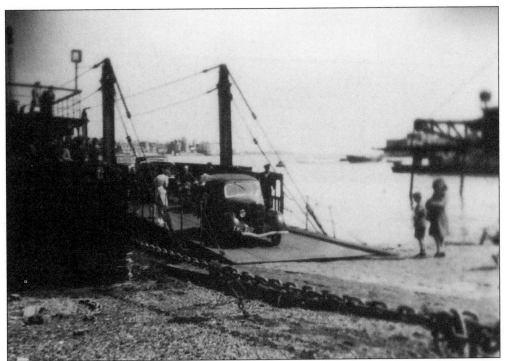

A car drives off the Floating Bridge c. 1950. The first Floating Bridge began operations in 1840 and the service ceased in 1959. It offered the quickest and most convenient route for vehicles crossing the harbour from Gosport to Portsmouth, taking less than fifteen minutes.

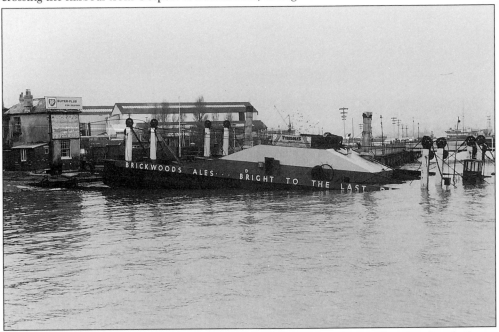

An ignominious end to the Floating Bridge as she lies semi-submerged at her Beach Street slipway in about 1960. Soon after this photograph was taken she was cut up for scrap. Vehicles must now make the long road journey round the harbour to get to Portsmouth.

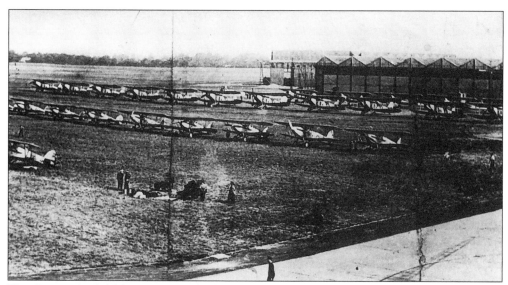

The Grange Airfield (now HMS *Sultan*) in 1933. Ranks of biplanes are parked on the grass in front of the huge hangers. This was originally home to the Royal Flying Corps and later the Special School of Flying. Several of the original aircraft hangers can still be seen at HMS *Sultan*.

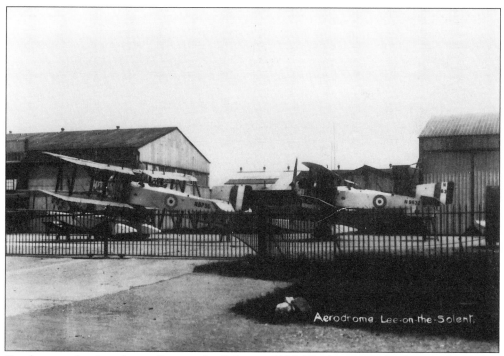

Seaplanes at the Aerodrome, Lee-on-the-Solent *c.* 1935. The large gates lead across the road to a concrete slipway which was used to launch the seaplanes. The slipway has also been used by hovercraft, but is now mainly used to launch jet-skis and other pleasure boats.

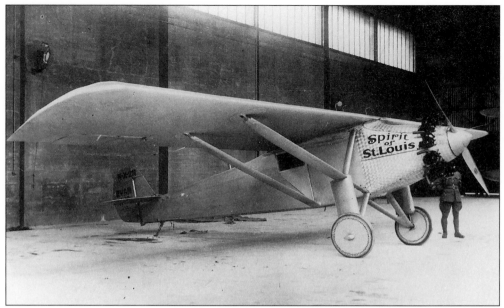

Charles Lindbergh made the first solo crossing of the Atlantic in 1927 in the *Spirit of St Louis* a 220hp monoplane. He flew from Long Island to Paris to win a prize of $25,000. The plane was later flown on to Grange Airfield in Gosport (now HMS *Sultan*), seen here in one of the large hangers, prior to being crated and shipped by boat from Southampton back to the United States.

The Gosport Spitfire 1943. During the Second World War, towns and cities throughout Britain collected funds to support the war effort. In 1941 the people of Gosport raised £5,000 to build this Spitfire.

Four

Sailmaking

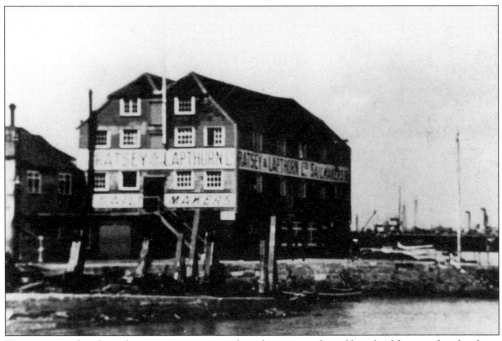

Boats required sails and it is not surprising that the two trades of boatbuilding and sailmaking flourished side by side in Gosport. The oldest and a nationally respected firm was Ratsey and Lapthorn, located close by the Camper and Nicholson boatyard. This is probably the original sail loft which dated from the firm's foundation in 1790 but was destroyed by enemy bombs during the Second World War.

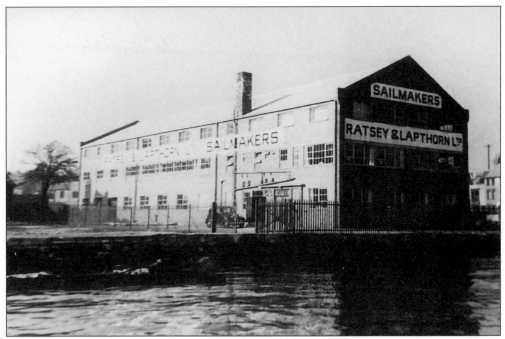

The new Ratsey and Lapthorn sail loft built after the Second World War to replace the old loft destroyed in the Blitz.

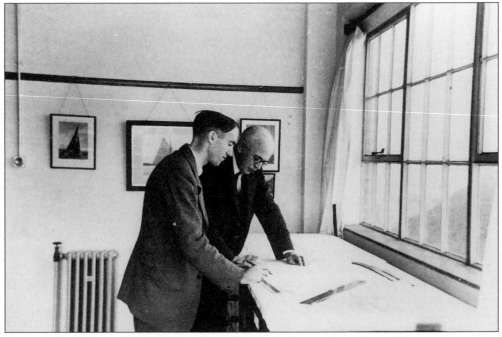

J. Stanley Lapthorn and James F. Lapthorn discuss the design of a sail c. 1950.

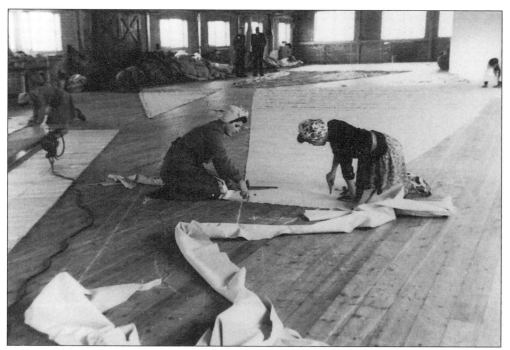

Girls cutting a sail on the spreading floor in the sail loft *c.* 1950.

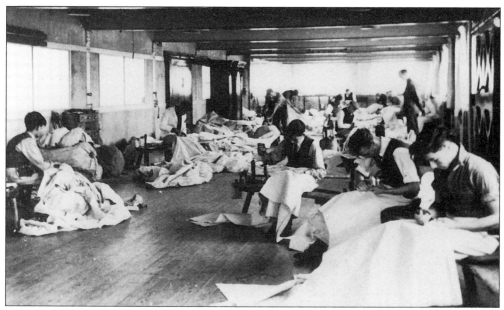

Sailmakers seaming and finishing sails *c.* 1950.

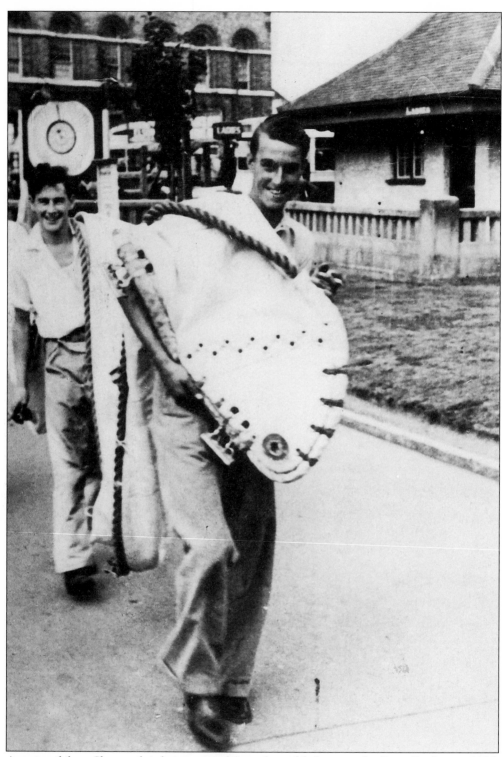

A mainsail from Shamrock is being carried from the sail-loft across the Ferry Gardens c. 1934. The old Market House can be glimpsed in the background c. 1934.

Five
Model Yachting

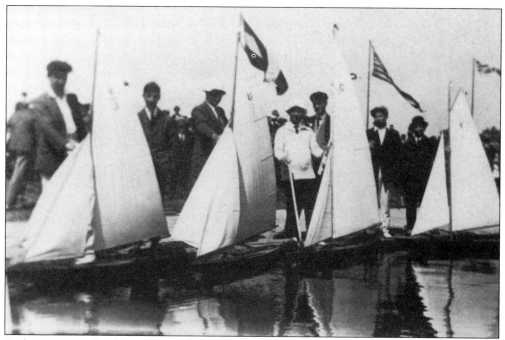

Enthusiasts proudly show their model racing yachts at the Model Yacht Lake in Walpole Park
c. 1935. In the early 1920s the Model Yacht Lake was created from the former 'Cockle Pond' in
Walpole Park. The Gosport Model Yacht Club was soon to become one of the premier venues
for national and international model yacht racing.

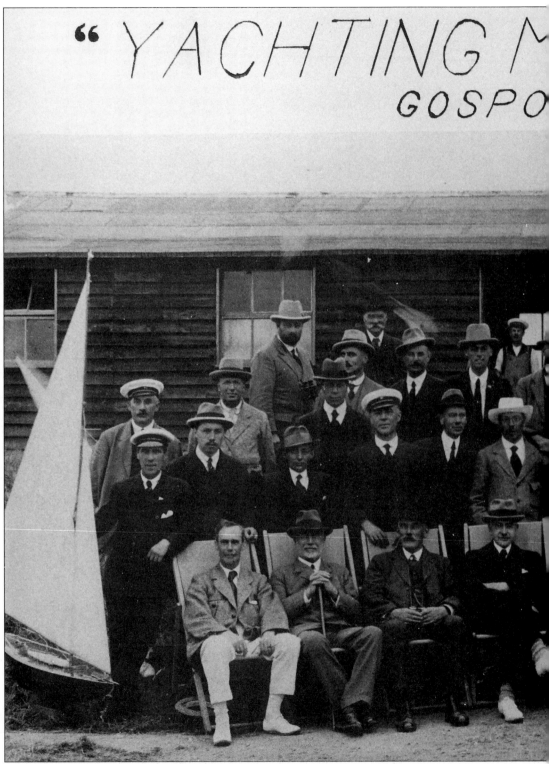

"YACHTING M
GOSPO

Local model yacht racers and visiting members of other model yacht clubs meet in Gosport for

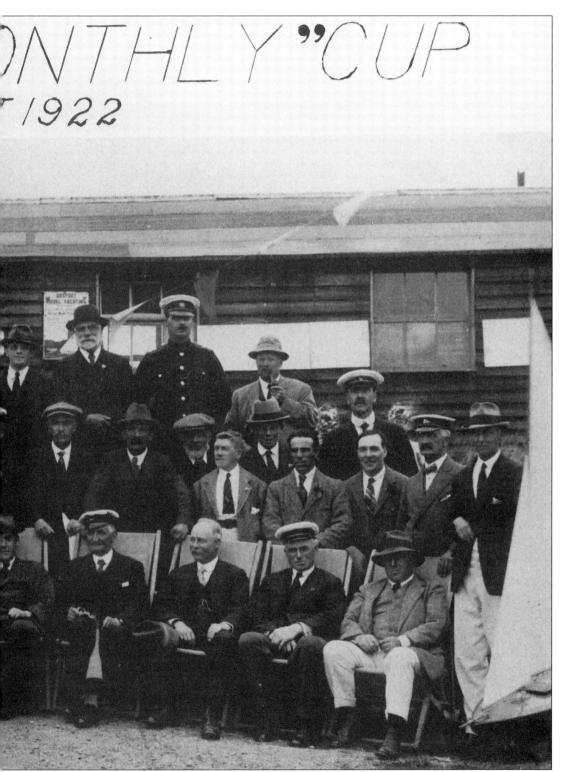

the prestigious *Yachting Monthly* Cup 1922.

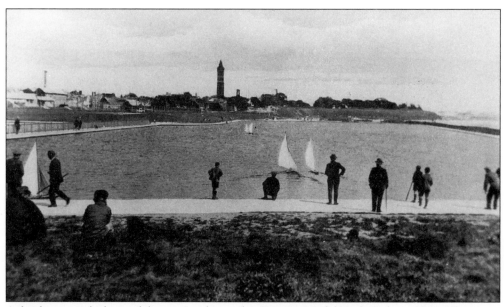

A few boys watch the model racing yachts at the Gosport Model Yacht Lake *c*. 1930. The tower of Holy Trinity Church can be seen in the distance.

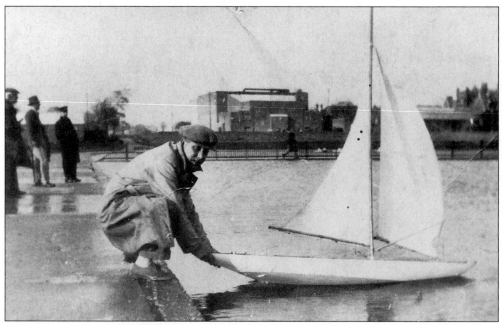

A proud model yacht racer launches his vessel *c*. 1937.The Ritz cinema dominates the skyline behind the Model Yacht Lake.

Six
The Public Health

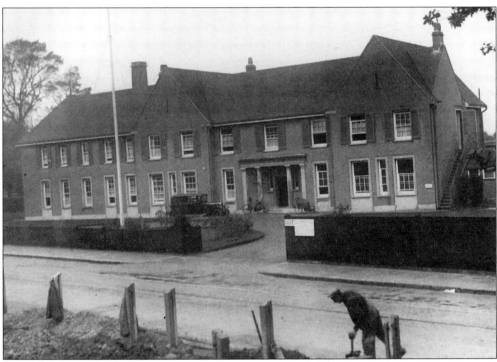

Gosport War Memorial Hospital, Bury Cross soon after its opening in 1923. The War Memorial Hospital was built by public subscription as a memorial to all those who lost their lives during the First World War and as the official memorial to the Royal Marine Light Infantry. There were originally 26 beds in the hospital.

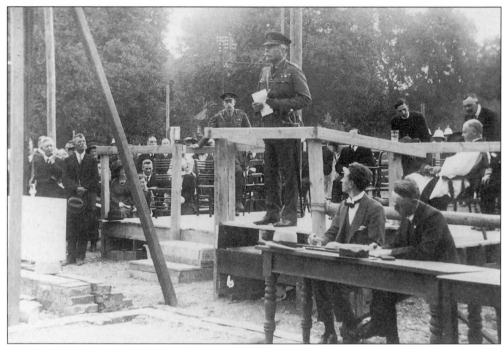

The foundation stone of the Gosport War Memorial Hospital laid by the famous First World War soldier Earl Haig on 3 July 1921. It was a further two years before the hospital was completed and opened for patients.

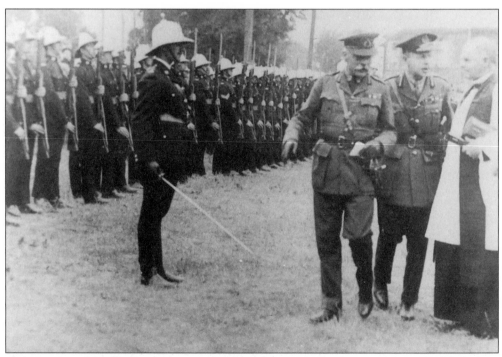

Earl Haig passing a Royal Marines guard of honour prior to his departure from the foundation stone laying ceremony.

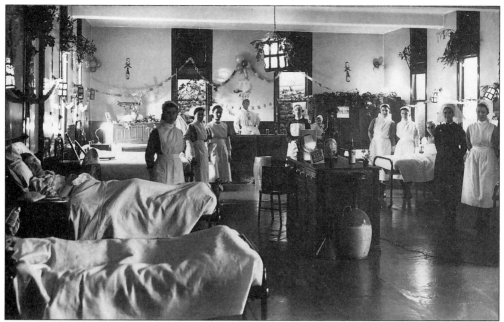

Christmas 1939 in one of the wards at the War Memorial Hospital. The decorations appear to have been provided by a brewery. A huge bottle of Mackeson is standing on the central workstation, whilst a large stoneware flagon is in front and an enormous barrel can be seen in the background. All for medicinal purposes one must assume!

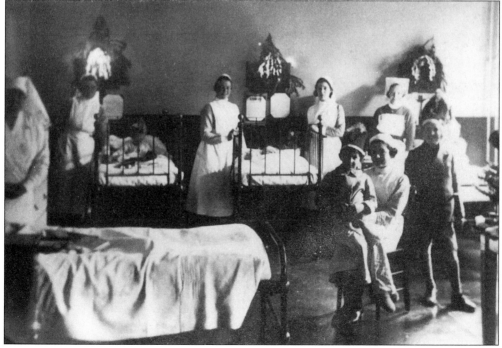

Happy faces on the Children's Ward, War Memorial Hospital, Christmas 1939.

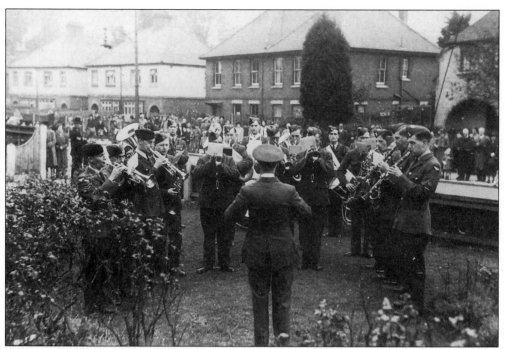

An RAF band play outside the War Memorial Hospital *c*. 1942. The houses of Bury Road can be seen in the background.

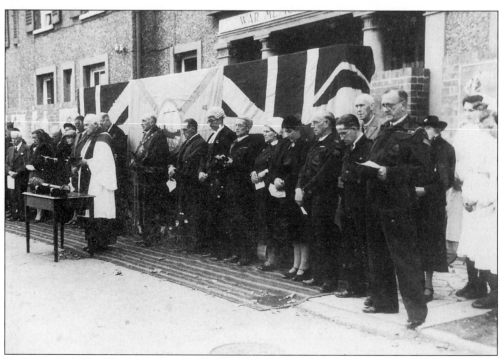

Dedication of 'Civil Defence Services Bed' at the War Memorial Hospital October 1944.

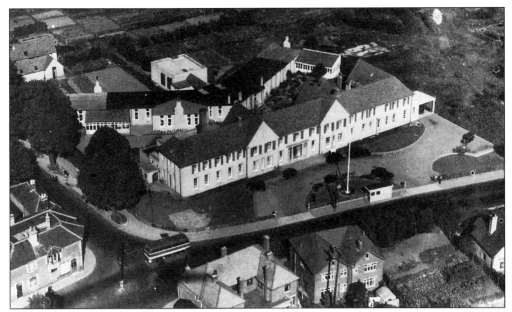

Aerial view of the War Memorial Hospital c. 1935. The hospital, opened in 1923, was later extended in 1932 to accommodate 42 patients and again in 1948 with an additional 21 beds. Note the vacant building plot on the opposite side of the road which is now filled.

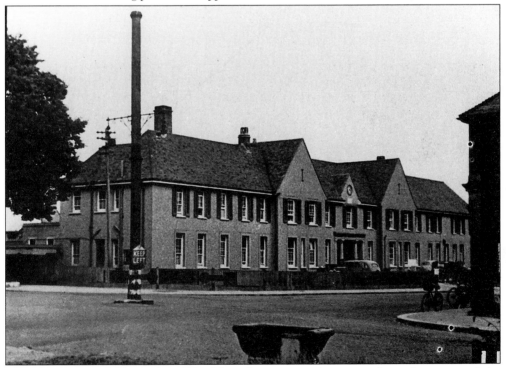

The War Memorial Hospital c. 1950. Note the cast iron horse trough on the corner of the Avenue and Bury Road. More recently, the hospital has undergone an extensive extension and rebuilding programme which was completed in 1995. A modern building was erected behind the original frontage which has been restored to its former glory.

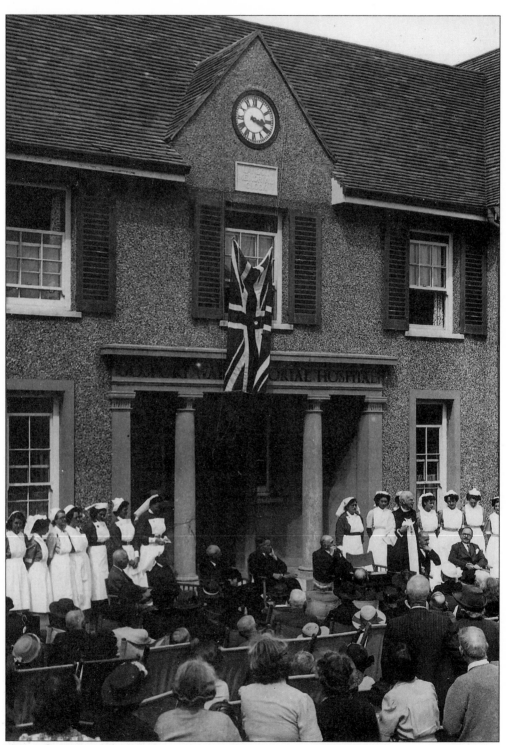

Nurses flank the main entrance of the War Memorial Hospital for the unveiling of the Landon Memorial Clock on 13 July 1950. A small gable was added above the main entrance to accommodate the clock. The union flag has just been lowered to unveil the clock.

Seven

A Royal Occasion

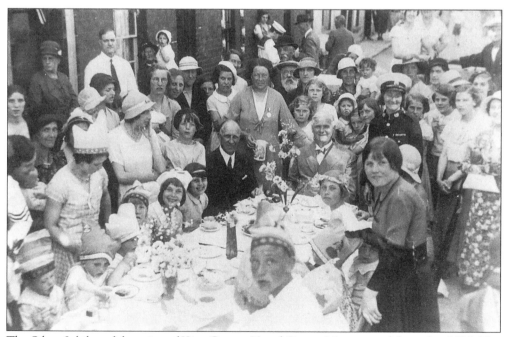

The Silver Jubilee of the reign of King George V and Queen Mary was celebrated in 1935. The Mayor, Councillor Ford, was the special guest at this street party in Henry Street, Gosport.

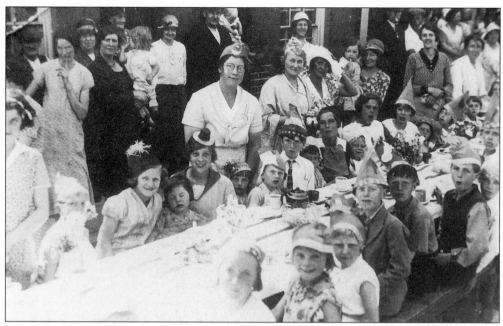

Adults and children celebrate at the Henry Street Silver Jubilee Party 1935.

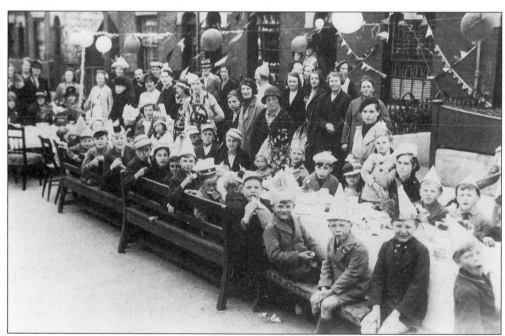

Another good excuse for a street party, this time in Joseph Street where residents enjoy the celebrations to mark the coronation of King George VI and Queen Elizabeth in 1937.

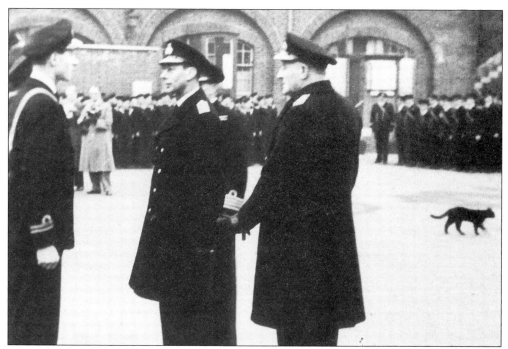

His Majesty King George VI on an inspection visit to Fort Blockhouse (now HMS *Dolphin*) *c.* 1942. The cat crossing the parade ground appears indifferent to the royal presence.

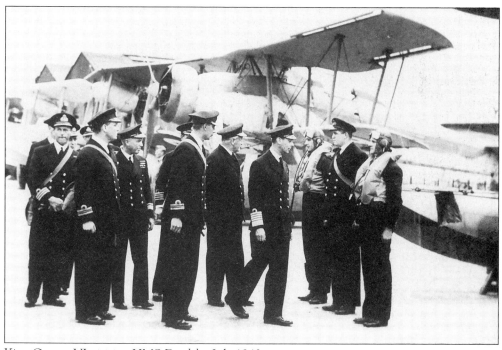

King George VI visiting HMS *Daedelus* July 1940.

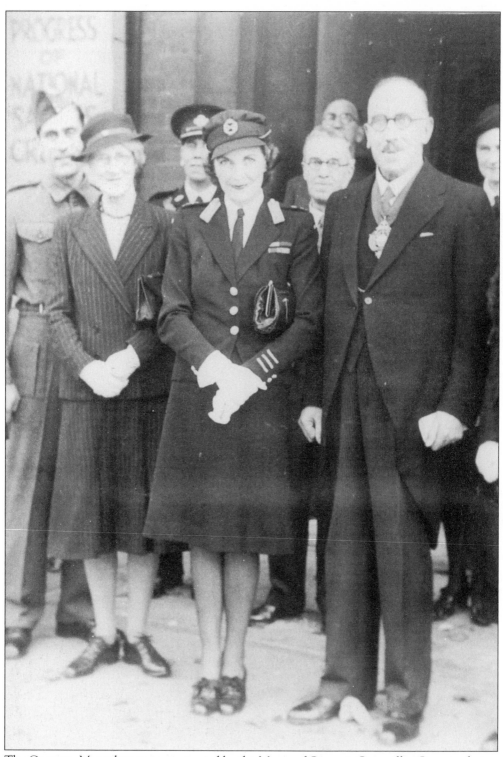

The Countess Mountbatten accompanied by the Mayor of Gosport, Councillor Gregson during a fund raising visit to Gosport *c*. 1944.

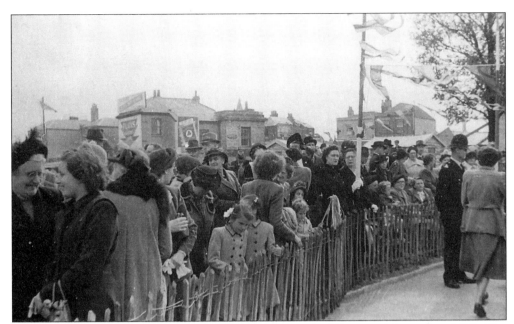

Crowds at the Ferry Gardens patiently await the arrival of Princess Margaret *c.* 1950. The buildings of Beach Street can be seen in the background.

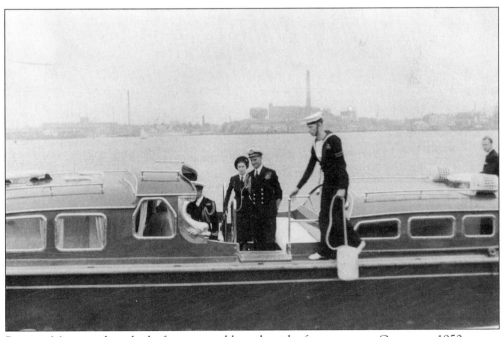

Princess Margaret disembarks from a naval launch at the ferry pontoon Gosport *c.* 1950.

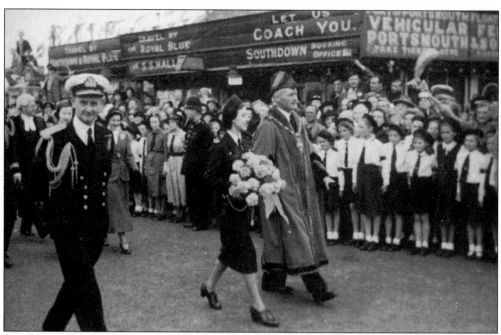

Accompanied by the Mayor, Charles Osborn, Princess Margaret passes the assembled onlookers, passing the ferry ticket office on her way through the Ferry Gardens.

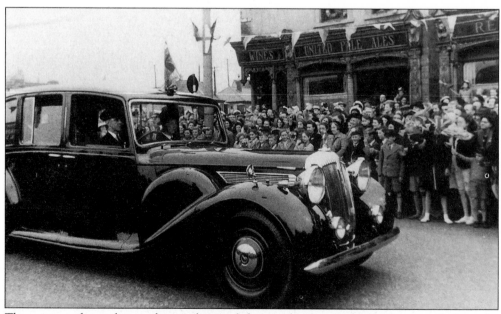

The princess then takes to the royal car, while crowds of excited onlookers watch from the pavement outside the Isle of Wight Hoy Tavern on the High Street.

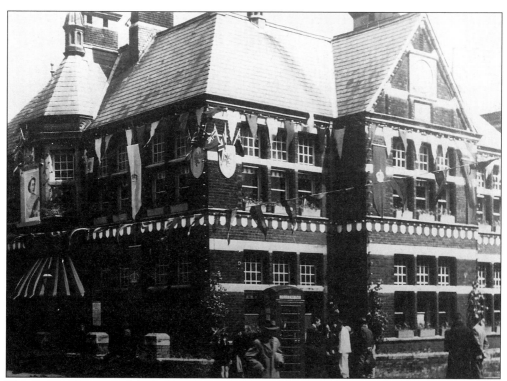

The Gosport Town Hall bedecked in bunting to mark the Coronation of Queen Elizabeth II in 1953.

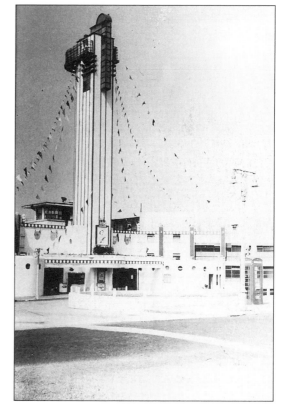

Lee Tower, Lee-on-the-Solent, is similarly adorned with bunting . Note the official portrait of the Queen which decorates both buildings 1953.

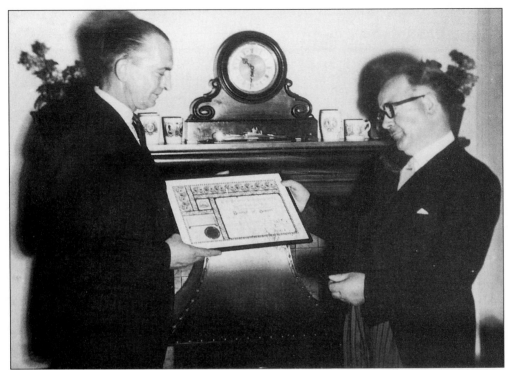

In the Mayor's Parlour in the Town Hall, the Mayor of Gosport, Councillor Eales, receives the 'Loyal Address' from Mr W. Bond of the Borough Engineers. The 'Loyal Address' was sent to Queen Elizabeth II by the Borough to mark her Coronation in 1953.

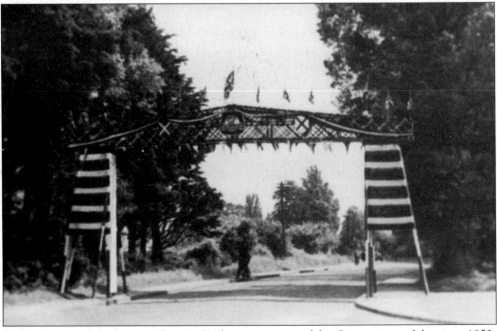

A decorative arch built somewhere in Bridgemary as part of the Coronation celebrations 1953.

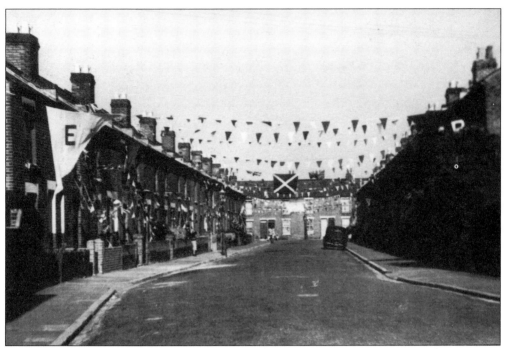

The residents of Pelham Road decorated their street with bunting (above) for the Coronation of Queen Elizabeth II and held a street party (below) to mark the occasion, 1953. The children in fancy dress are ready for a day of fun!

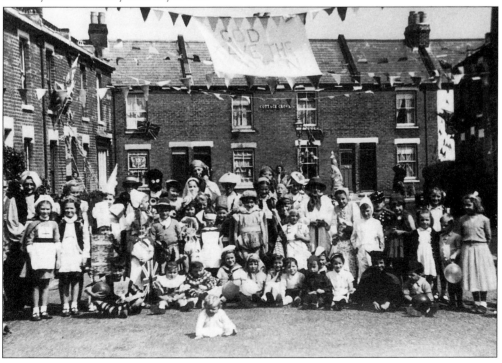

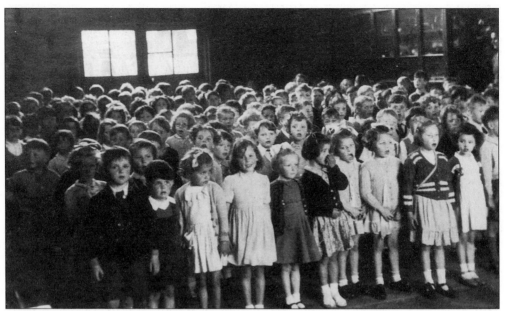

Young children at Stone Lane School patiently await in the school hall for the presentation of Coronation Mugs, which were given to every child in the Borough, 1953.

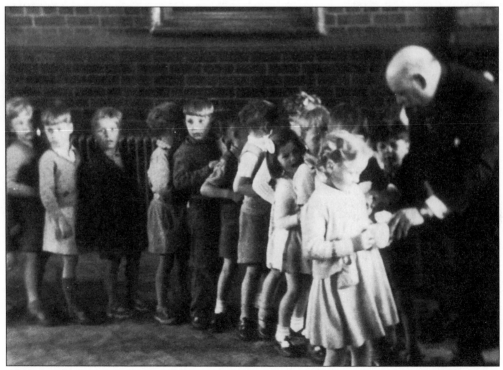

Alderman I Morgan presents a Coronation Mug to each child from Stone Lane School 1953.

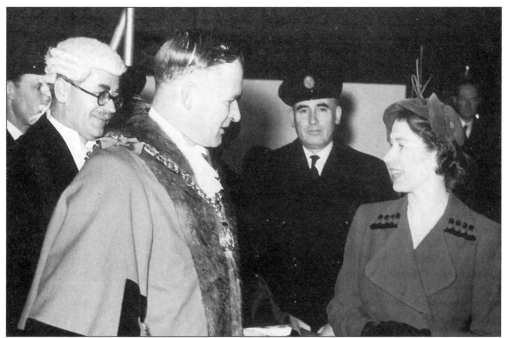

Mayor of Gosport Charles Osborn greets Queen Elizabeth II at Fort Brockhurst station 1952.

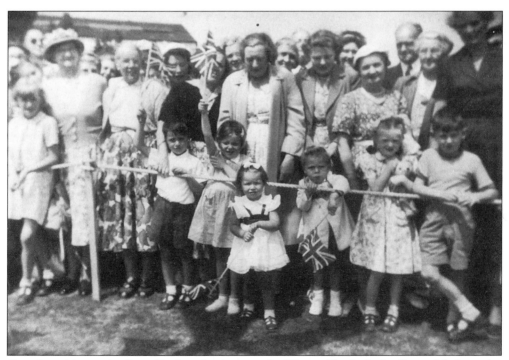

Crowds waiting at the Ferry Gardens for the arrival of Queen Elizabeth the Queen Mother prior to her visit to Northcott House 1955.

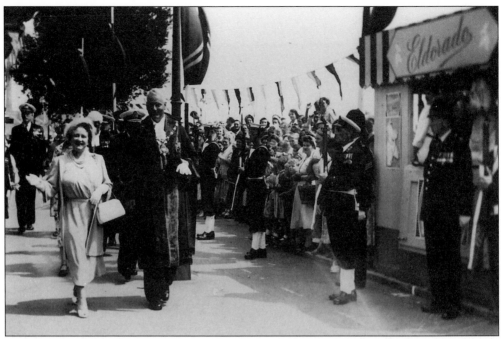

The Queen Mother, accompanied by the Mayor, Councillor Trevor Rogers, passes a naval guard of honour at the Ferry Gardens on her way to open Northcott House 1955.

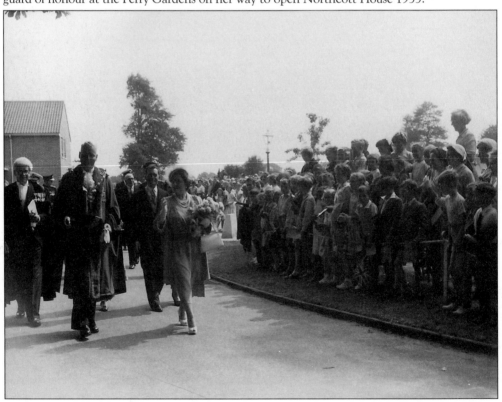

More crowds watch the arrival of the Queen Mother at Northcott House 1955.

Eight

Schooldays

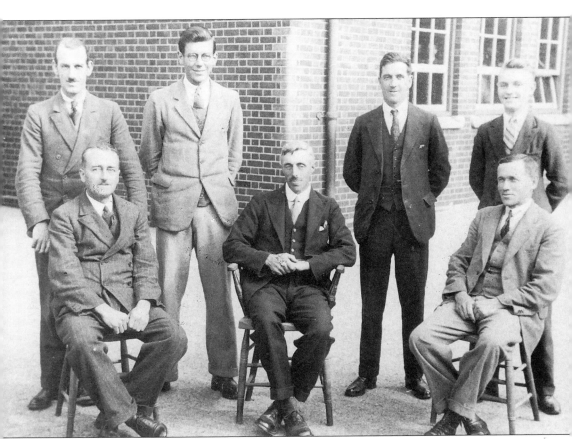

Staff at Clarence Square School *c.* 1930. Seated (centre) is Mr Keep, the headmaster of the school.

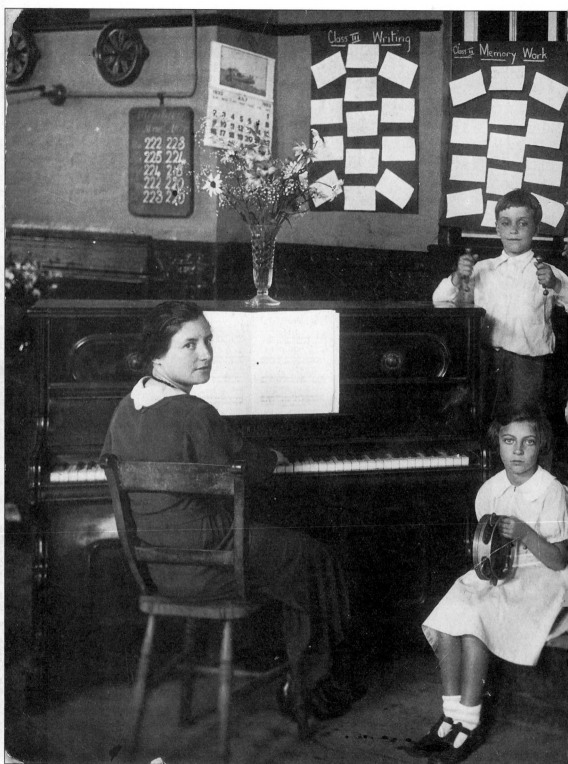

The music class at Newtown School Grove Avenue 1933.

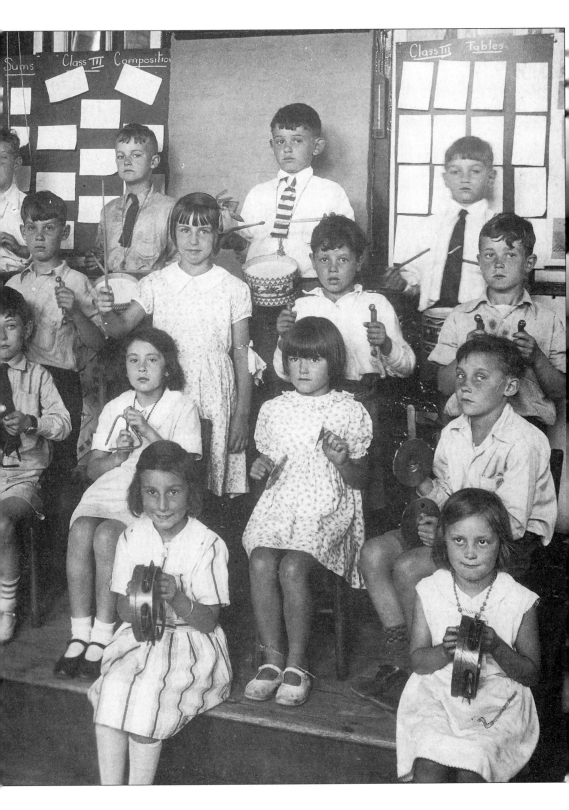

65

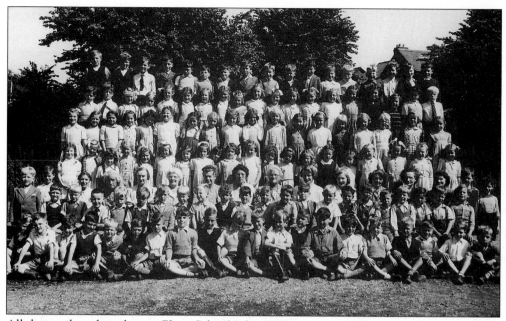

All the pupils and teachers at Elson School July 1950.

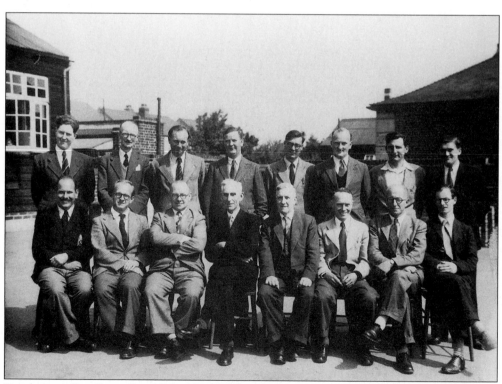

Teaching staff at Grove Road School *c.* 1955.

Privett School *c*. 1950. The school was demolished in the early 1980s. The playing fields remain as Privett Park and the school site is now a housing estate.

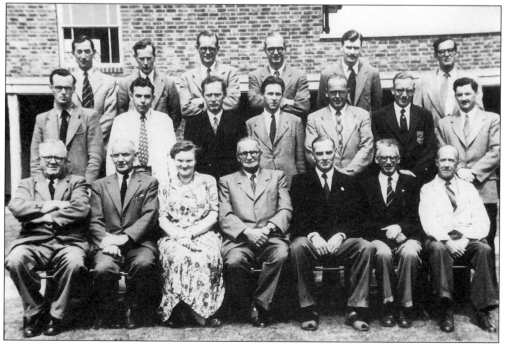

Teaching staff of Privett School 1960.

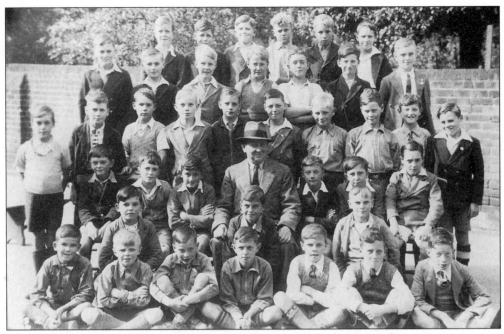

Class 1 Newtown Boys School 1936. Their teacher was Mr Budge (centre).

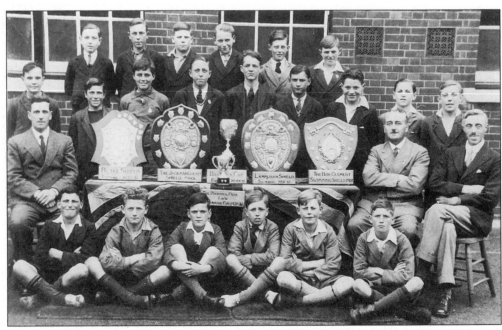

Showing off the sporting honours at Clarence Square School 1934.

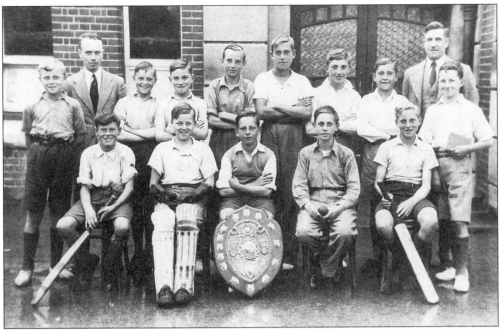

Cricket Team Grove Road Boys School 1930.

Privett Boys School intermediate cricket team 1952.

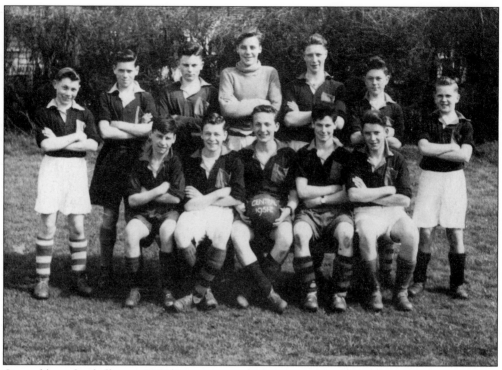

Central boys football team 1951/2.

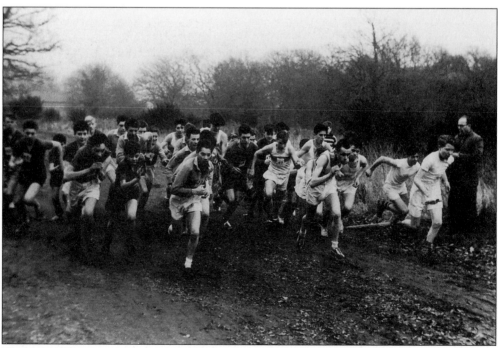

The start of the inter-schools cross country race at Browndown 1959.

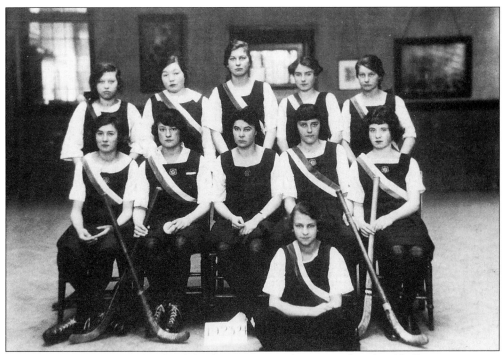

The Gosport Grammar School girls hockey team 1923/4 pose in the school hall.

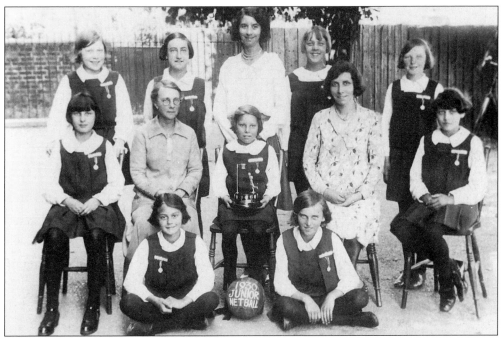

Newtown Girls School netball team 1930.

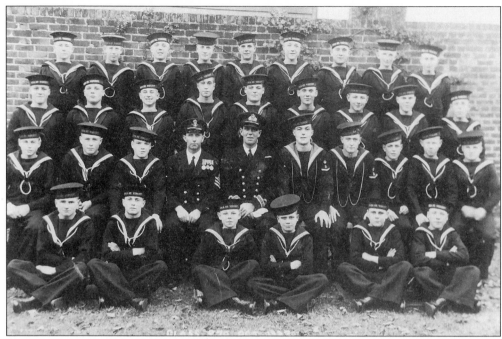

HMS *St Vincent* was a boys' training 'ship'. This group shows the class of October 1932. On the reverse side of the original print are the hand-written words ' Dear Mum, I am the 2nd from the right 3rd row'. We do not know who he was or why he thought his mother wouldn't recognise him!

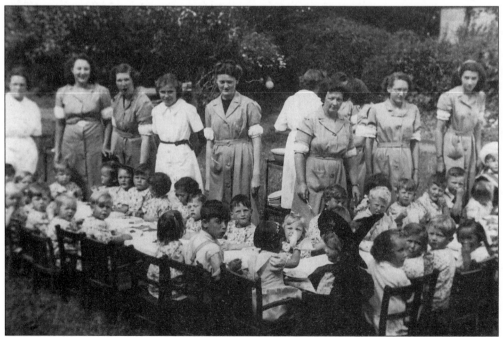

The staff and children of Podd's House day nursery, Brockhurst Road *c.* 1953.

Nine

All In A Day's Work

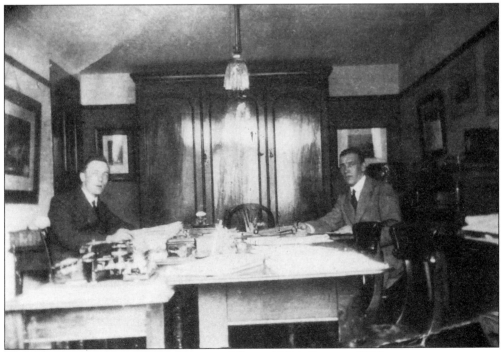

Inside the Gosport Waterworks Company Offices, 4 High Street *c.* 1930

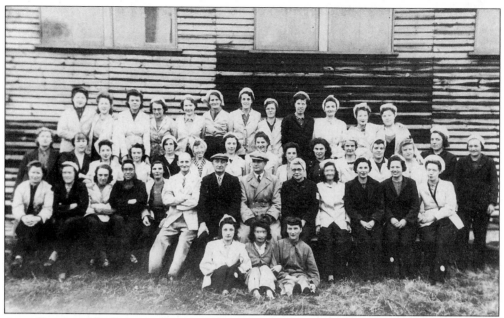

A small group of the large workforce of armaments workers at Priddy's Hard 1944.

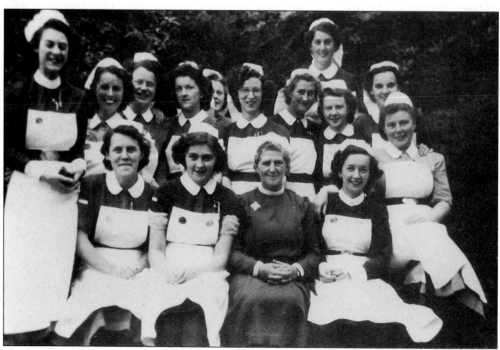

The starched white aprons of nursing staff, Gosport War Memorial Hospital, July 1950.

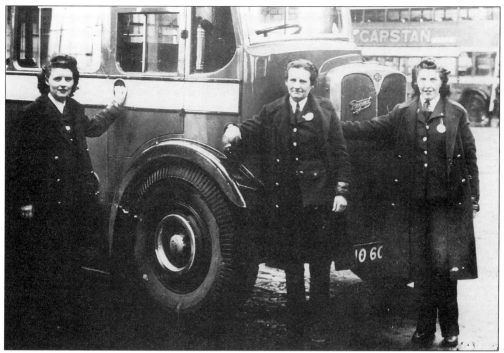

Women bus drivers for Provincial Bus Company *c.* 1948.

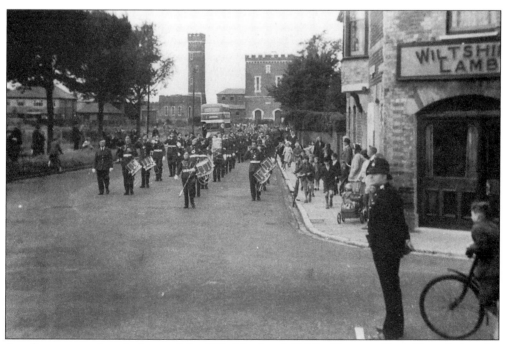

A policeman on duty in front of the Wiltshire Lamb Public House at Bury Cross during the Remembrance Sunday Parade *c.* 1946.

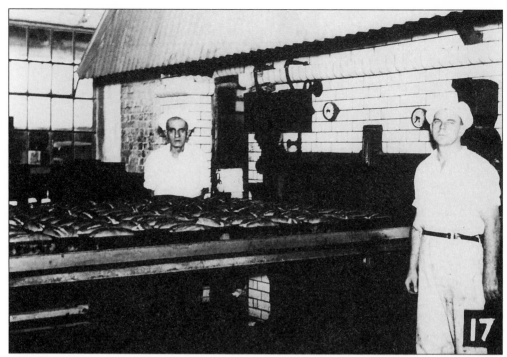

Aylings Bakery in Chapel Street, Hardway, was the largest bakery in the Borough, supplying bread and confectionery throughout the area. At the time of this photograph in 1950, Aylings employed about one hundred people. Here loaves of bread are being unloaded from one of the large ovens.

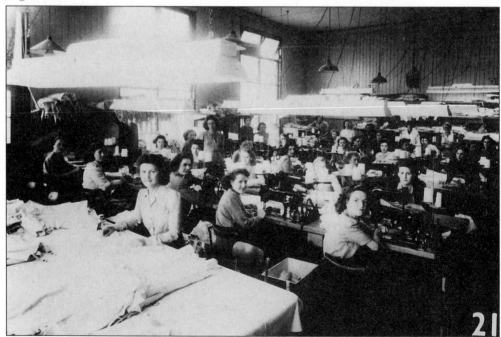

The staff in the temporary building of the Harris and Parkin Corset Factory in North Street c. 1950.

Ten

On the Road

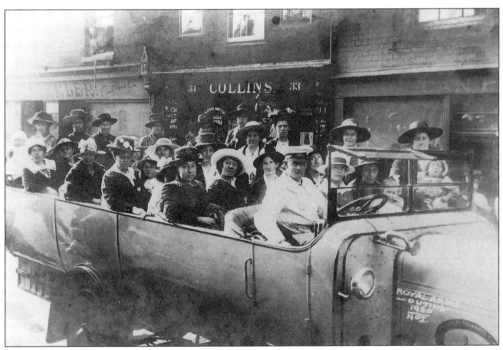

Royal Arms Outing 1920. A Provincial Bus Company charabanc parked on Stoke Road in front of Collins tobacconists at 33 Stoke Road. To the left Buckler's outfitters at 31, and on the other side was Miss Cantle's for general supplies.

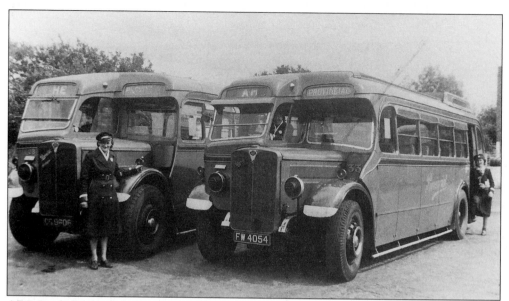

AEC Single Decker buses were introduced onto routes in and around Gosport by the Provincial Bus Company in 1934. This photograph was obviously taken in the 1940s showing the blackout blinds attached to the headlights.

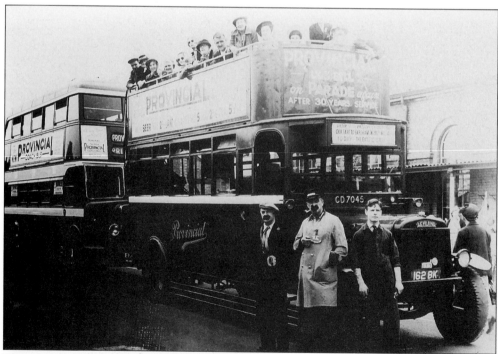

These two buses were built more than thirty years apart. Both were run by the Provincial Bus Company, although the old Leyland bus, known as 'Old Bill' has been specially brought out for the Gosport Carnival 1953. The driver and conductor appear to be getting into character by wearing ridiculous false moustaches!

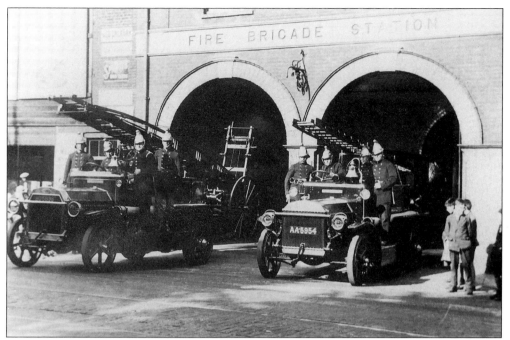

Fire engines and firemen outside the main Gosport Fire Station, Clarence Road, *c.* 1920.

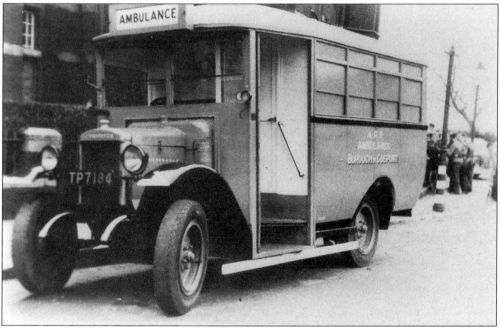

Gosport ARP Ambulance 1942. This former Provincial bus was converted to become the Gosport ARP Ambulance. Seen here parked outside the Town Hall, it was operated by the Gosport Air Raid Precautions rescue unit, and no doubt was kept busy helping the numerous casualties following the many bombs which fell on the Borough in the early 1940s.

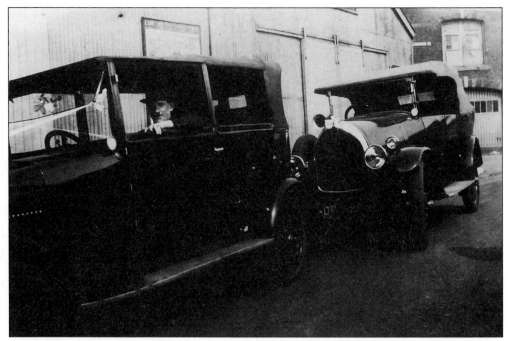

Two of Tutts Taxis, run by Harvey Tutt in Gosport c. 1930.

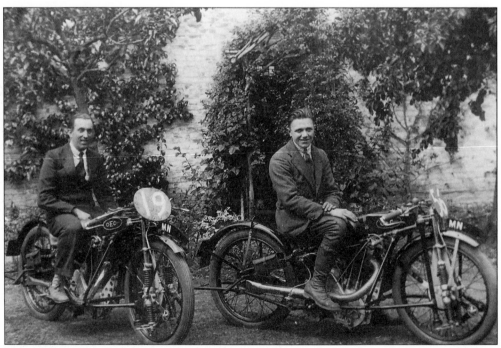

The OEC motorcycle company built machines in their factory at Lees Lane, Gosport, although the business later moved to Portsmouth. Their motorbikes saw success at the Isle of Man TT races. This photograph was probably taken for publicity purposes in the 1920s. It clearly shows the unusual front suspension and their JAP engines.

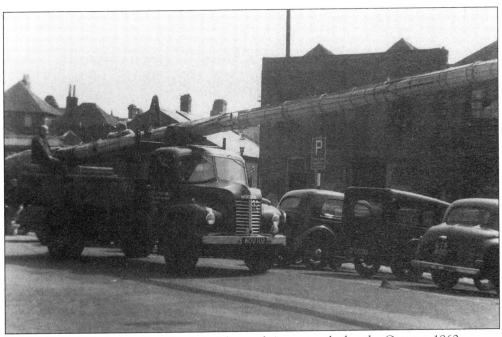

A Camper and Nicholson lorry loaded with a yacht's mast parked at the Green *c*. 1960.

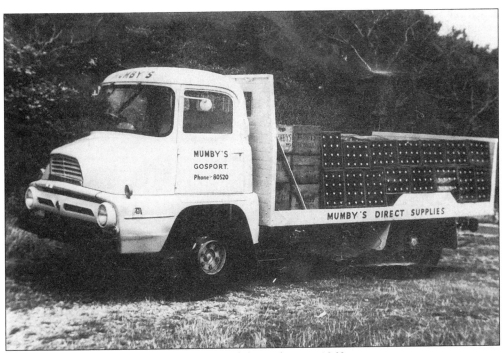

Mumby's new lemonade and mineral water delivery lorry *c*. 1960.

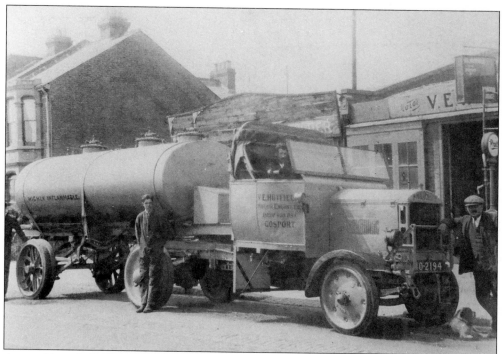

A petrol lorry belonging to Hutfield Motor Engineers outside the works at 73 Brockhurst Road *c*. 1925.

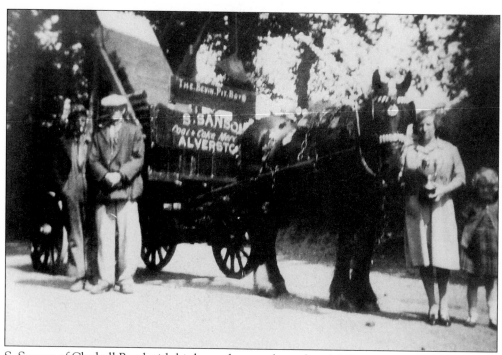

S. Sanson of Clayhall Road with his horse drawn coke and coal delivery wagon *c*. 1950.

Eleven

Civic Duties

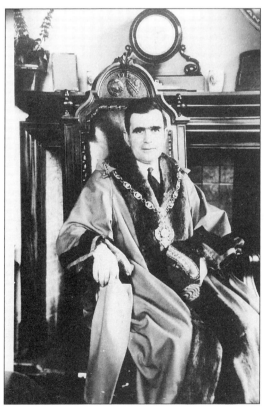

Mayor Nobes poses in the mayoral chain of office and robes in the Mayor's Parlour in Gosport Town Hall 1946. On the mantelpiece to the right of the clock is a commemorative mug produced by the Borough to mark the Silver Jubilee of King George V in 1935.

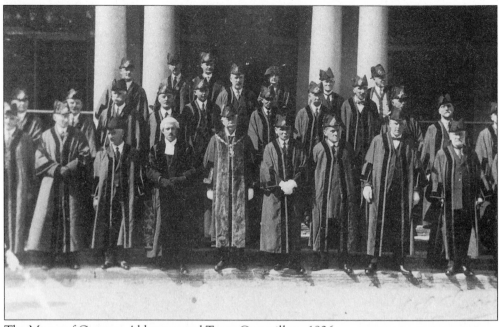

The Mayor of Gosport, Aldermen and Town Councillors, 1926.

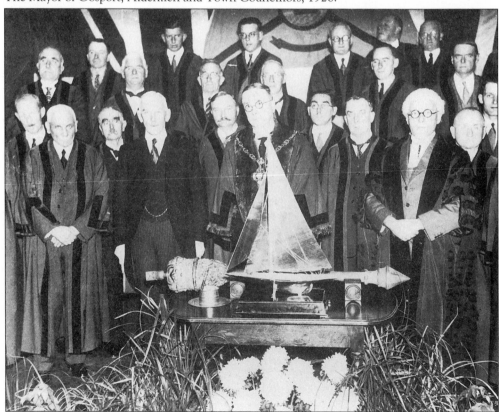

Charles Nicholson (of Camper & Nicholson) surrounded by the Mayor and local councillors on the occasion of the award of the Freedom of the Borough of Gosport 5 November 1934.

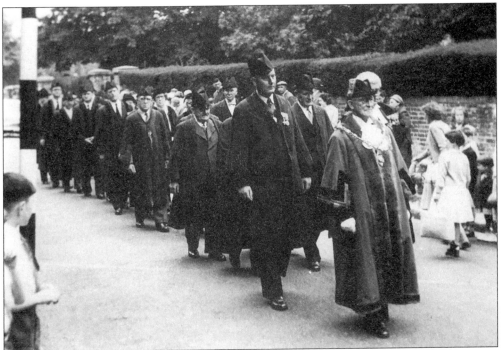

Former Mayors, Councillors, Aldermen, Freemen of the Borough of Gosport 1959.

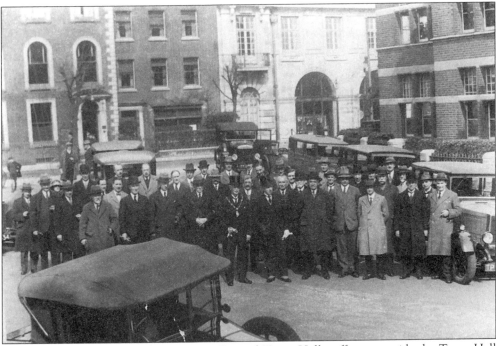

The Mayor and Gosport Urban District Council Town Hall staff pose outside the Town Hall c. 1922. No. 4 High Street on the left of the picture has little altered, however the old Gosport District Gas Company building and most of its neighbours have long gone.

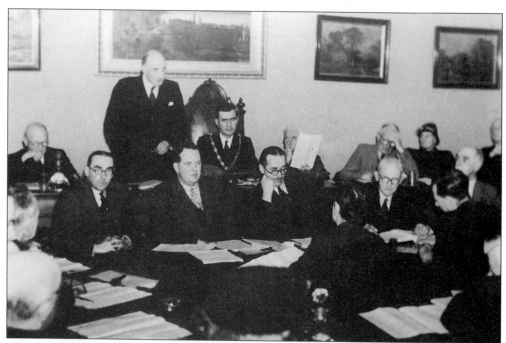

Mayor Nobes (seated centre) while Alderman Gregson (standing) addresses the Town Council in the Council Chamber at the Town Hall *c.* 1946.

Inside the Mayor's parlour, Gosport Town Hall *c.* 1950.

Twelve

By the Seaside
at Lee-on-the Solent

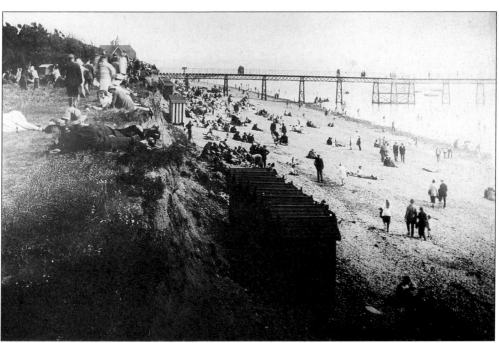

The beach at Lee-on-the-Solent c. 1925. Here are the typical English beach huts and, of course, the pier. On hot summer days the pebbly beach could become crowded with day visitors and local people, most of whom are well clothed despite the obviously warm weather.

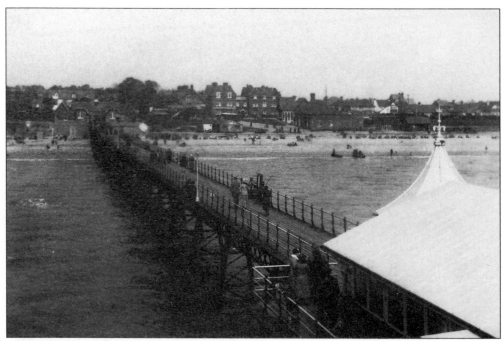

Views from the end of the pier *c.* 1920. Towards the end of the nineteenth century, Lee-on-the-Solent was promoted as a seaside resort, and although it was popular with local people and visitors it never rivalled the main seaside resorts of the south coast. The large seafront villas built between the 1890s and 1920s provided their owners with splendid views across the Solent to the Isle of Wight.

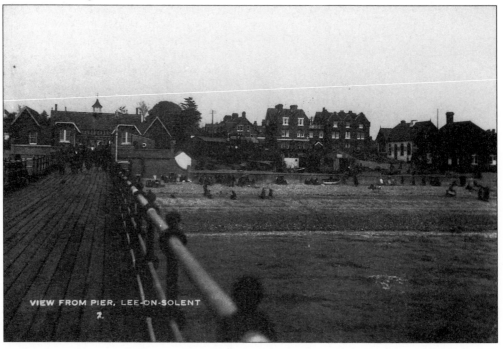

VIEW FROM PIER, LEE-ON-SOLENT

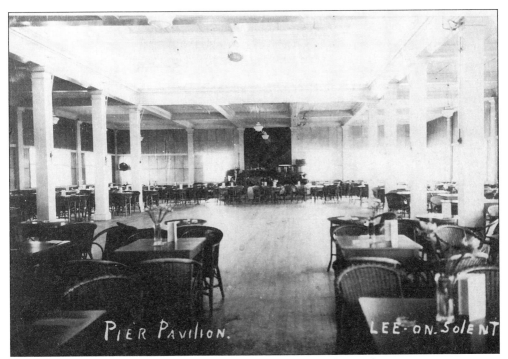

This photograph is captioned Pier Pavilion at Lee-on-the-Solent. The structure appears too substantial and large to have been built on the pier. Perhaps readers will remember whether this really stood at the end of the pier or perhaps that it was part of the later Lee Tower complex.

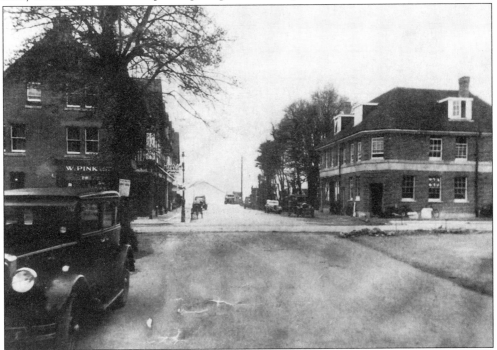

Pier Street looking towards the sea 1934. On the right W. Pink, on the left the Midland Bank. The plot of land behind the bank is vacant prior to the Marine Parade development.

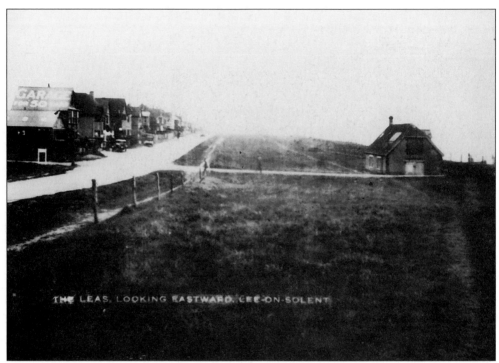

THE LEAS, LOOKING EASTWARD, LEE-ON-SOLENT

On a quiet day, the Lee front could be quite deserted. Skippers Garage provided space for fifty cars and is probably empty on the day this picture (above) was taken, yet on the Schneider Cup race day 1929 (below), the entire seafront became one long car park to accommodate the hundreds of spectators who came to watch the air race.

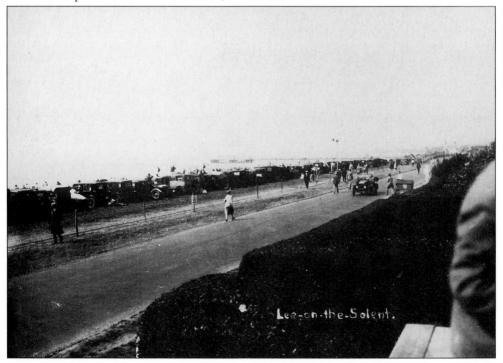

Lee-on-the-Solent.

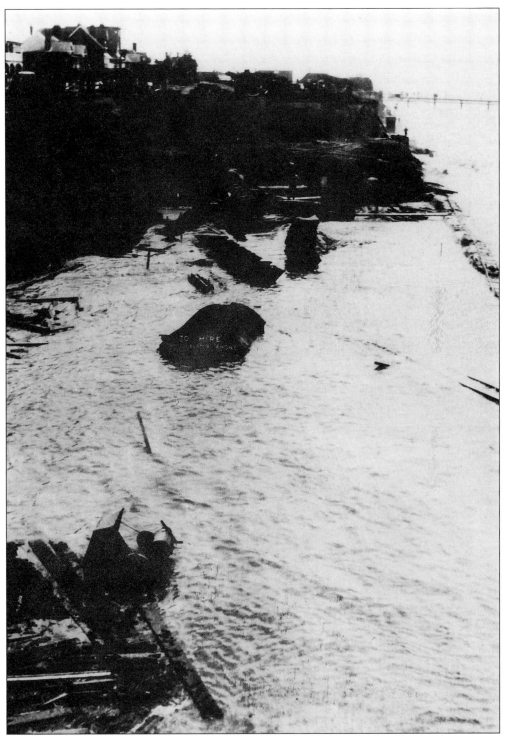

In 1931 work began on the construction of a heated seawater swimming pool to the west of the Lee Tower. On this occasion the particularly high tide and stormy onshore winds prematurely filled the site with sea water!

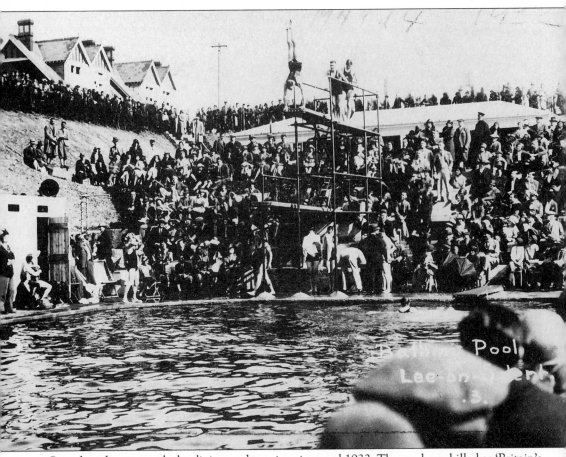

Crowds gather to watch the diving at the swimming pool 1932. The pool was billed as 'Britain's First and Only Open Air Heated Sea Bathing Pool at the fashionable South Coast Resort, Lee-on-the-Solent'. This photograph was used on the cover of the pool's advertising leaflet.

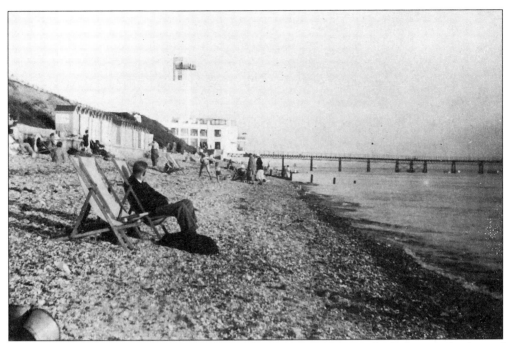

The Lee Tower and pier c. 1935. An additional attraction to Lee-on-the-Solent, in the form of the 110 foot tall Lee Tower, was added to the seafront in 1935 providing spectacular views across the Solent. It included a large restaurant sun terrace, dance hall and cinema.

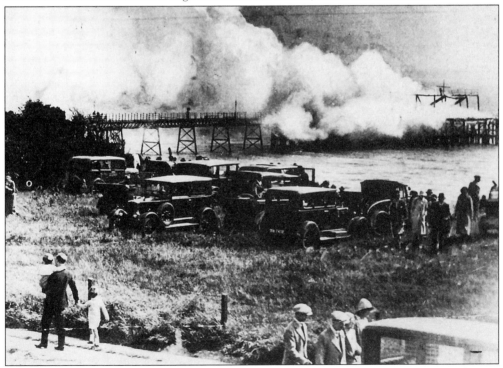

In 1935, a major fire engulfed the pier at Lee-on-the-Solent. The resulting damage left the pier unsafe and it was never rebuilt.

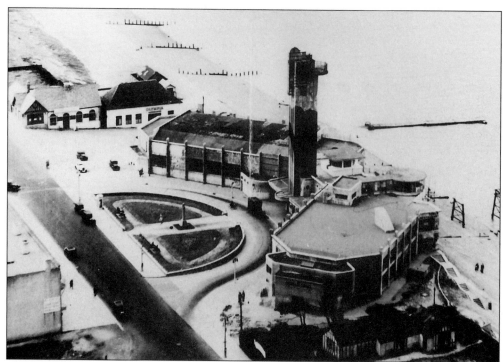

The Lee Tower was an obvious landmark for enemy aircraft during the Second World War, and as a consequence was camouflaged to make it less visible from the air. The remains of the pier were also rendered valueless to possible enemy landings from the sea.

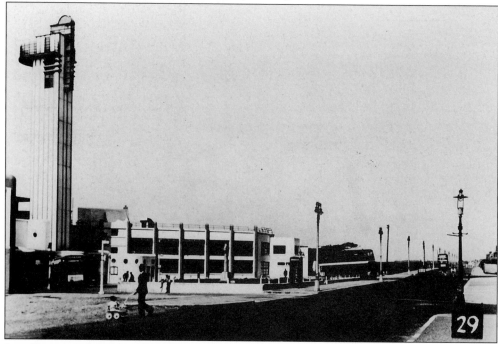

Lee Tower and Marine Parade *c.* 1950. Following structural problems, the Tower was demolished in 1971.

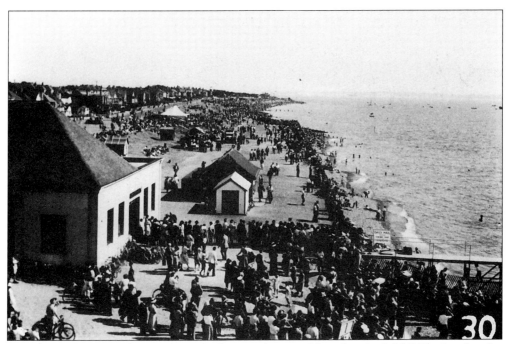

Views from the top of the Lee Tower looking to the west (above) towards Hill Head and to the east (below) towards Elmore *c.* 1950

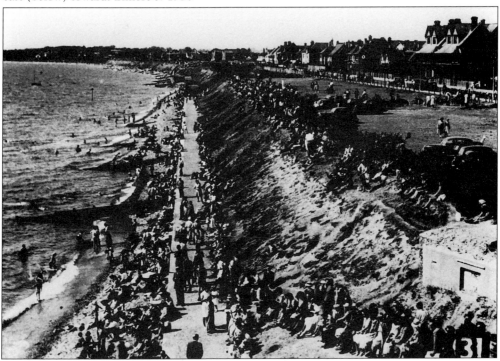

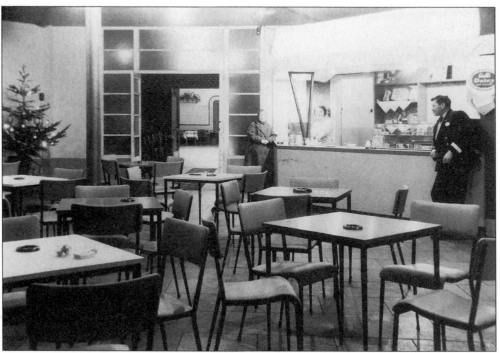

The cafeteria inside the Lee Tower *c.* 1960

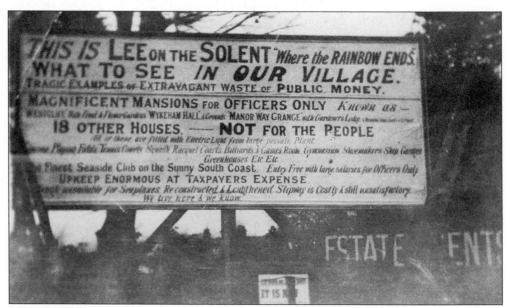

This signboard appeared very briefly in Pier Street, Lee-on-the-Solent, in about 1930 to protest about the impending extension of the military airfield (now HMS *Daedelus*).

Thirteen

The Blitz

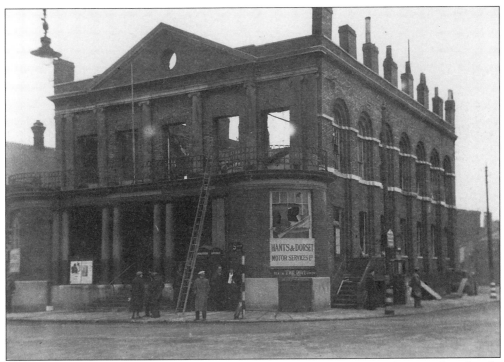

The Old Market House was one of many buildings in Gosport damaged by incendiary bombs during the Second World War. The direction sign to the public air raid shelter can be seen on the corner of the street outside the Dive. As well as public buildings, numerous houses and shops were damaged or destroyed by enemy bombs. The following few pages give some indication of the devastation!

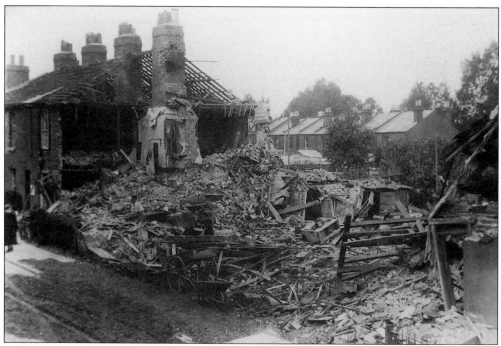

A wheelbarrow and handcart, probably there to help with the salvage of belongings, stand outside the remains of a house on Leesland Road.

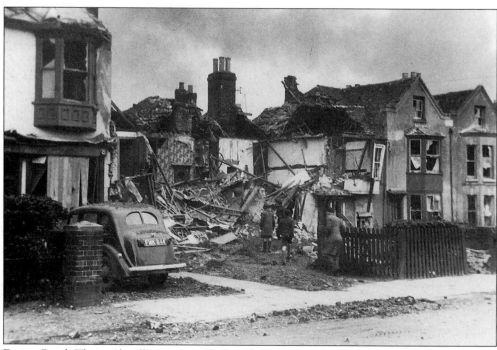

Forton Road. Three schoolboys survey the bomb damage while in the background black smoke is rising from burning fuel oil tanks.

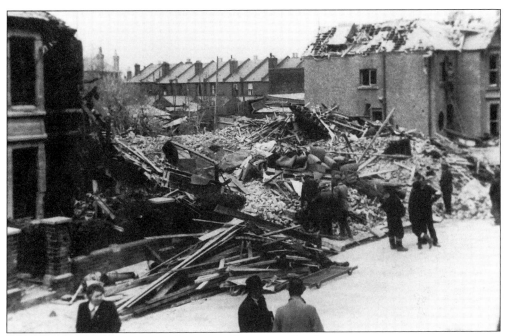

Onlookers survey the extensive damage at Hartington Road.

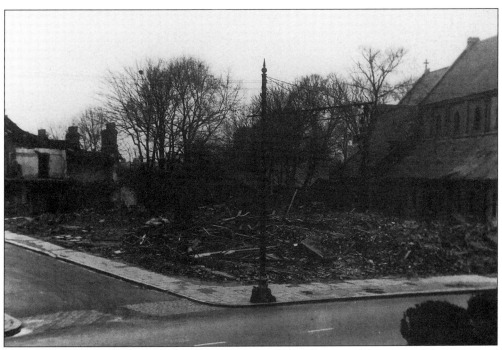

A pile of bricks and timber is all that remains of the shops and houses on the corner of Moreland Road and Forton Road. St John's Church can be seen to the right of the picture.

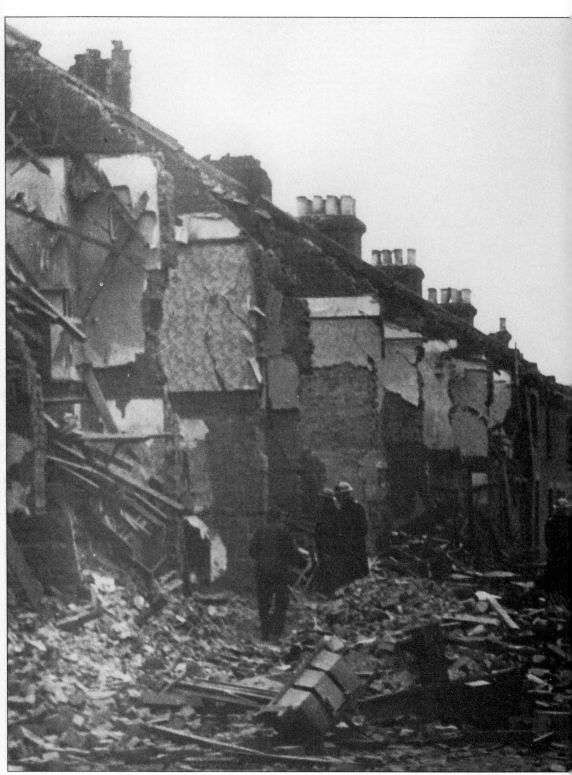

The total devastation of Avenue Road.

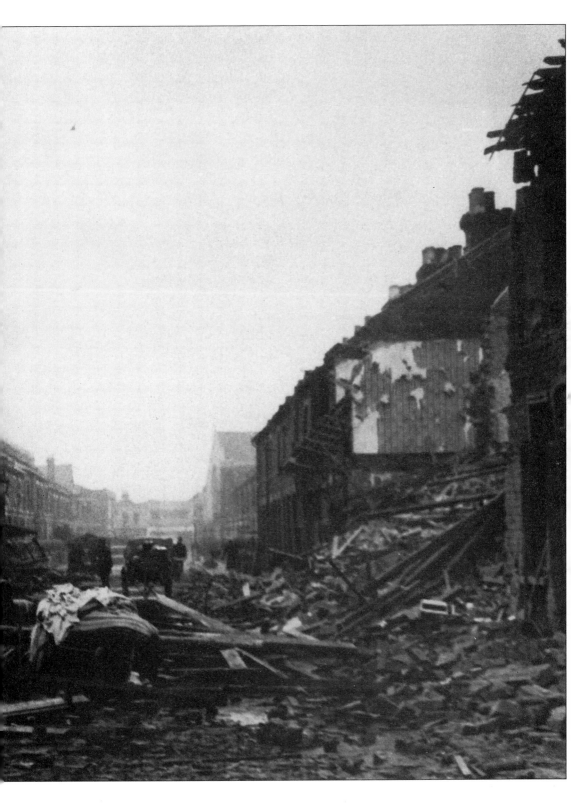

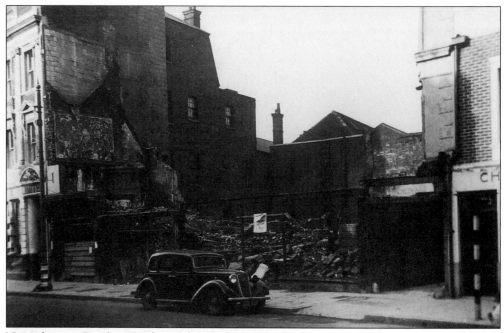

Next door to Barclays Bank on the High Street, the Home and Colonial Stores, Gunton Brothers Fruiterers and W.B. Smith's Chemists have been reduced to rubble by enemy bombs.

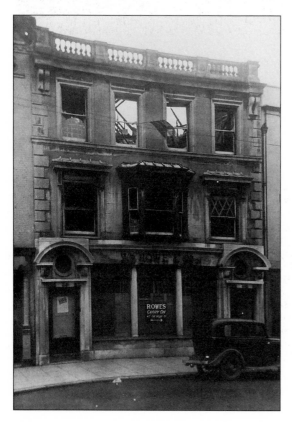

Bomb damage to W. Rowe, Tailors and Outfitters, 78 High Street. But for this long established Gosport retailer it was still business as usual at their other premises at 91 High Street.

Stuart Smith's furniture shop and Hubert Smith's restaurant in Beach Street will not be opening for business after a direct hit!

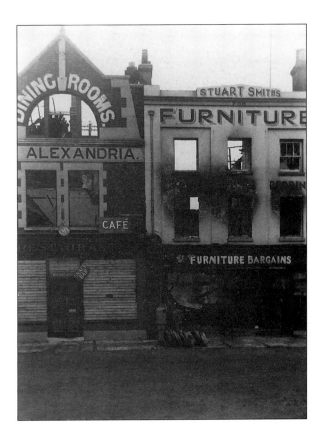

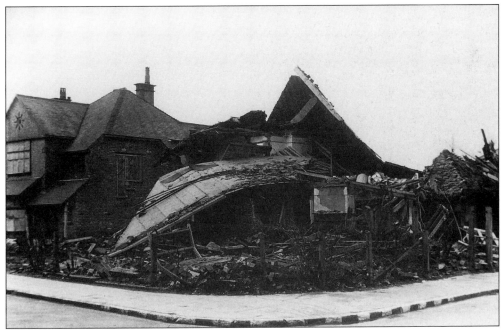

An entire house on the corner of Spring Garden Lane and Grove Avenue has been destroyed by a German bomb.

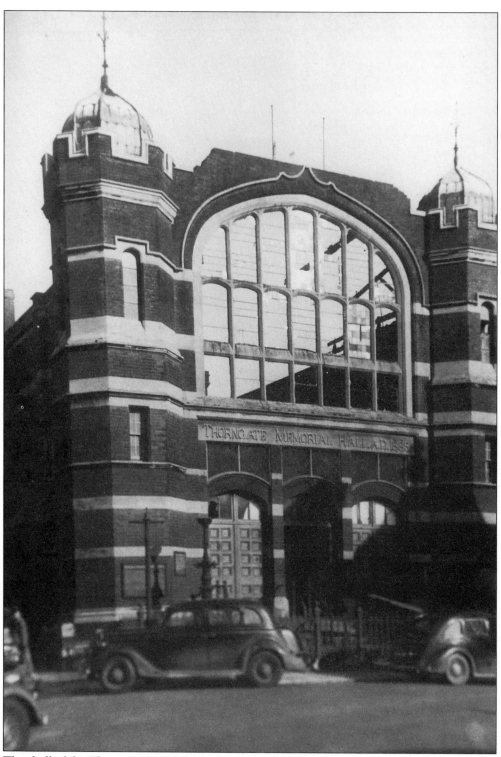

The shell of the Thorngate Hall, which was one of Gosport's finest Victorian buildings, gutted by a bomb.

Fourteen

Victory

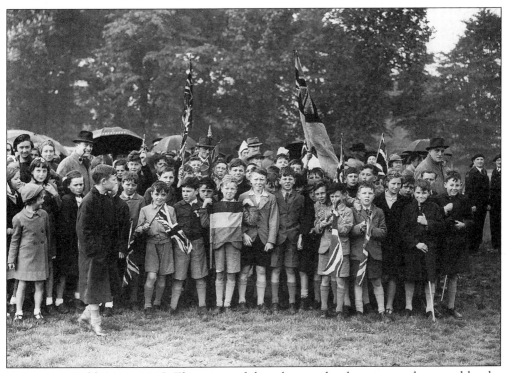

St George's Field 8 May 1945. The spirits of these boys and girls were not dampened by the weather whilst waiting to hear the official proclamation of peace at the end of the Second World War.

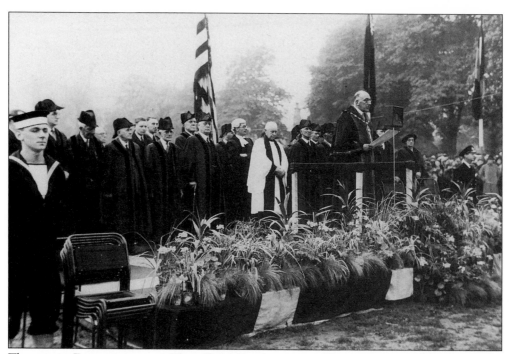

The war in Europe was over! The official Proclamation of Peace announced by Councillor Gregson in St George's Field on 8 May 1945.

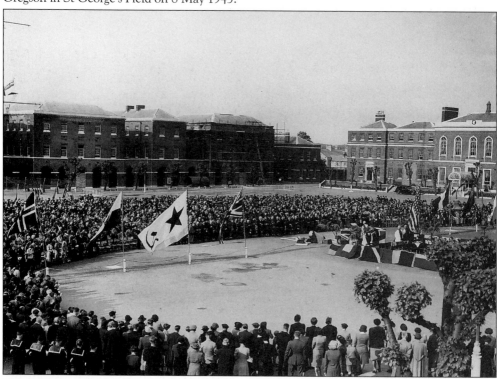

Victory Thanksgiving Service to mark the end of the war in Europe held on the enormous parade ground on HMS *St Vincent* 8 May 1945.

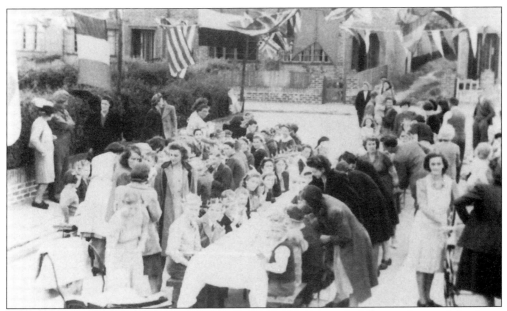

The Victory in Europe was celebrated throughout the Borough. The residents of Anthony Grove held their VE Day Street Party in Cedar Close during May 1945.

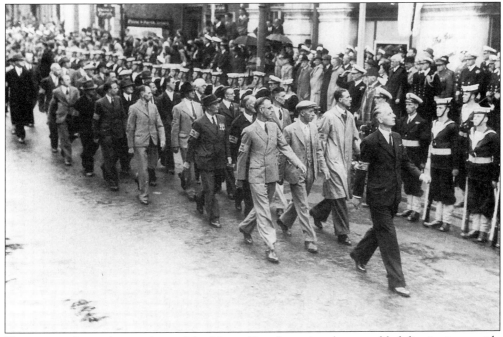

Victory march past by members of the Home Guard, passing the assembled dignitaries outside the Gas Company showroom in the High Street 1945.

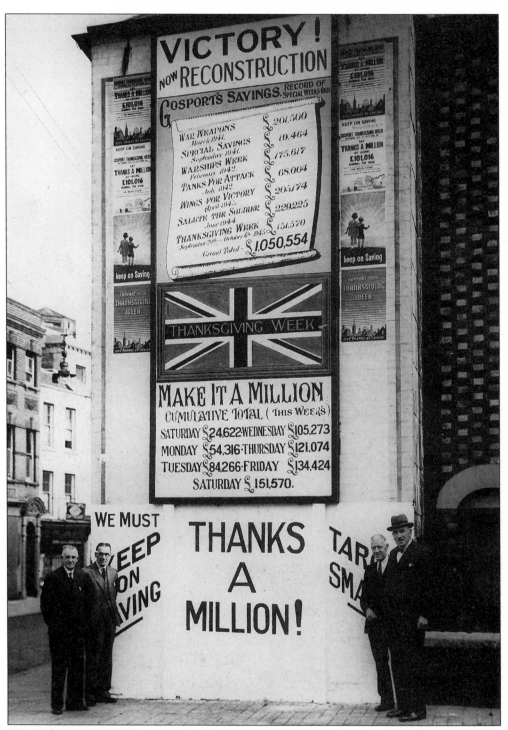

National Savings Thanksgiving Week 29 September to 6 October 1945. Throughout the Second World War, the people of Gosport raised many thousands of pounds to help the war effort, the results of which were displayed on this signboard outside the Town Hall.

Fifteen

The Changing Face
of Gosport

The old and the new *c*. 1960. There have been great changes to Gosport particularly due to the devastation caused by German bombs in 1940 and 1941. During the 1960s controversial plans to redevelop parts of the town removed many of the dilapidated, but historically and architecturally important eighteenth and nineteenth century buildings. In South Street the recently constructed tower blocks overlook old buildings soon to disappear.

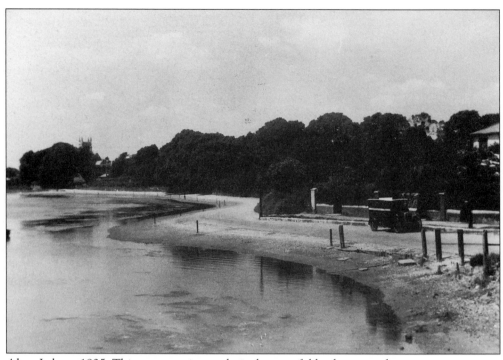

Alver Lake *c.* 1925. This area remains a relatively peaceful backwater today.

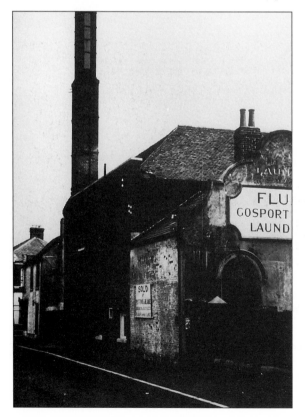

Flux's Laundry, Haslar Street *c.* 1939. The laundry advertised that it had its 'own artesian well of pure water' and 'open air drying grounds'. The laundry chimney was a town centre landmark until the 1960s.

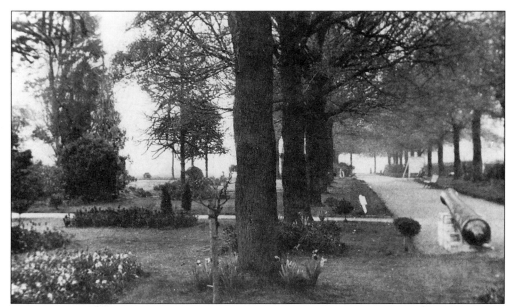

An ornamental cannon in Gosport Park *c*. 1930. Formerly waste ground of Ewer Common, Gosport Park included sports pitches and a cycle track.

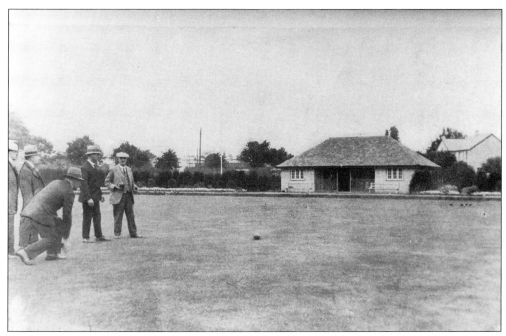

A leisurely game of bowls played at Anglesey Gardens *c*. 1930. The official Borough Guidebook of the time declares that the 'turf green ... is as near to perfection as human knowledge and ingenuity can make it'.

Walpole Park *c.* 1930. The Thorngate Hall can be seen in the far distance. Walpole Park stretched from Walpole Road right down to Alver Creek before it was split into two sections by the south relief road in the 1970s.

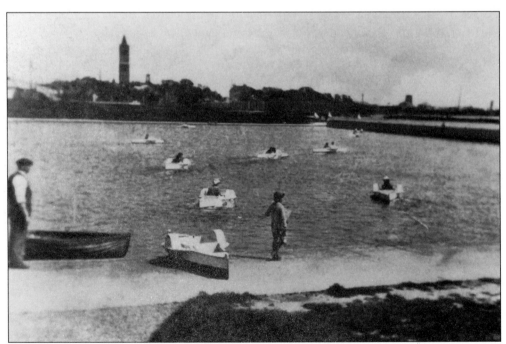

The Boating Lake, Walpole Park *c.* 1930. A section of the shallow Model Yacht Lake was set aside for children who could hire small paddle boats or rowing boats.

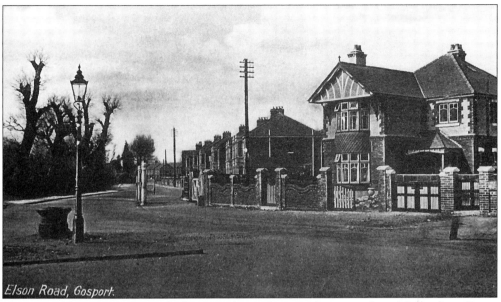

Elson Road, Gosport.

Elson Road has changed very little since these photographs were taken (above from Priory Road, below from Ham Lane) *c.* 1925. The road is now a busy thoroughfare and unlike then, never seen free of cars!

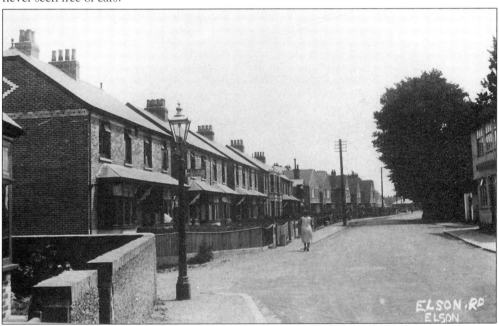

ELSON RD
ELSON

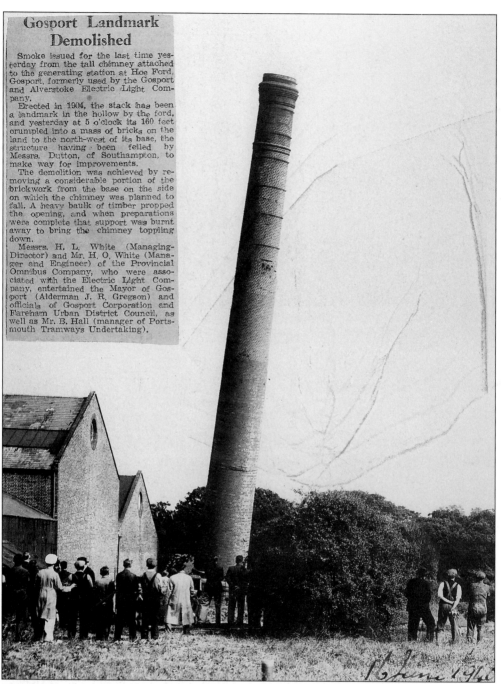

Gosport Landmark Demolished

Smoke issued for the last time yesterday from the tall chimney attached to the generating station at Hoe Ford, Gosport, formerly used by the Gosport and Alverstoke Electric Light Company.

Erected in 1904, the stack has been a landmark in the hollow by the ford, and yesterday at 5 o'clock its 160 feet crumpled into a mass of bricks on the land to the north-west of its base, the structure having been felled by Messrs. Dutton, of Southampton, to make way for improvements.

The demolition was achieved by removing a considerable portion of the brickwork from the base on the side on which the chimney was planned to fall. A heavy baulk of timber propped the opening, and when preparations were complete that support was burnt away to bring the chimney toppling down.

Messrs. H. L. White (Managing-Director) and Mr. H. O. White (Manager and Engineer) of the Provincial Omnibus Company, who were associated with the Electric Light Company, entertained the Mayor of Gosport (Alderman J. R. Gregson) and officials of Gosport Corporation and Fareham Urban District Council, as well as Mr. B. Hall (manager of Portsmouth Tramways Undertaking).

The demolition of the chimney of the electricity generation station at Hoeford in 1940. The electricity had been used to light the town of Gosport as well supply power for the electric trams.

Gomer Lane, looking towards Stokes Bay c. 1930.

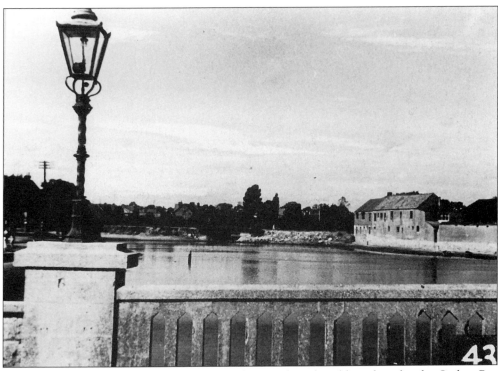

Workhouse Lake 1950. Viewed from the Alver Bridge, the old viaduct for the Stokes Bay Railway can be seen (centre) and on the right John Hunt's Builders Yard has now been replaced by a modern retirement homes.

Opening of first prefab on San Diego Road by Councillor Gregson 1945. Many new houses were required at the end of the Second World War to house 'bombed-out' families'. Prefabs (prefabricated houses) were seen as an effective and speedy method of providing cheap new homes.

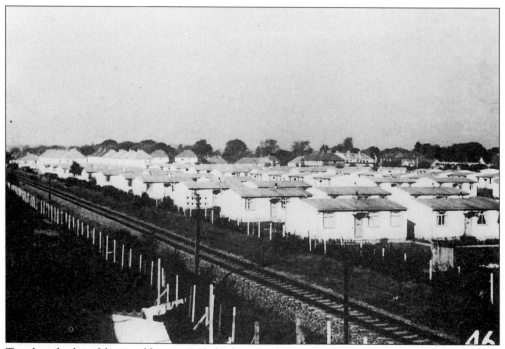

Two hundred prefabricated houses were built in Bridgemary, and were soon replaced by houses of bricks and mortar on the new Bridgemary Estate.

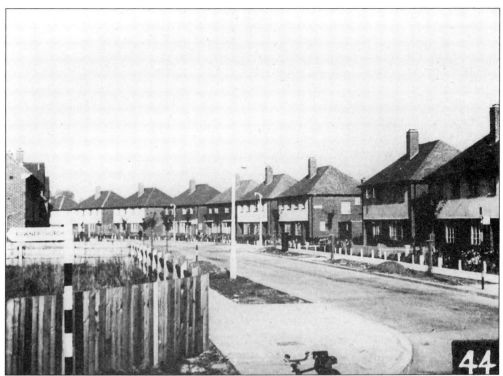

New houses of the Bridgemary Estate (above and below) c. 1950. One solitary bicycle in an otherwise empty estate with its well laid out paths and verges. The estate was developed after the Second World War as a complete neighbourhood providing new houses, shops, schools, churches and open spaces for the people of Gosport.

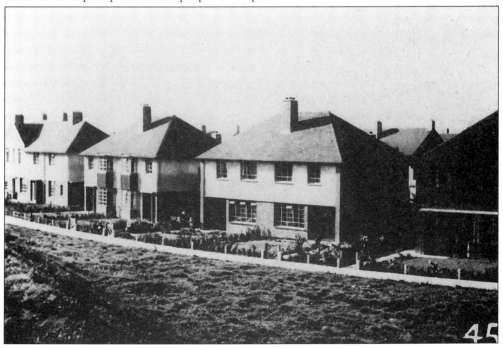

B15 Fire Station, Bury Cross *c*. 1950. The new Fire Station replaced it in the 1960s.

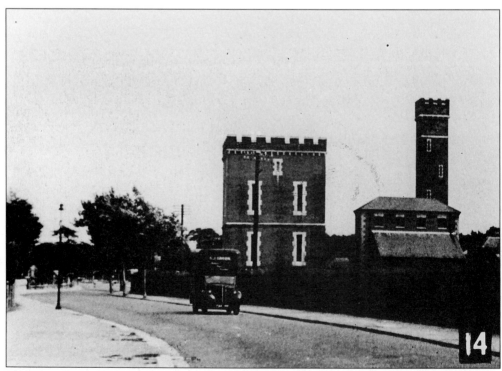

The Gosport Waterworks on Bury Road *c*. 1950. The waterworks was opened in 1858 to supply the town with fresh water. The last of the original buildings was demolished in 1994.

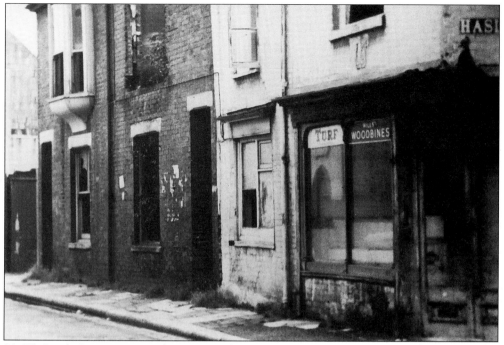

71–75 South Street, 20 October 1950. The buildings are derelict and await the wholesale redevelopment of this old part of the town.

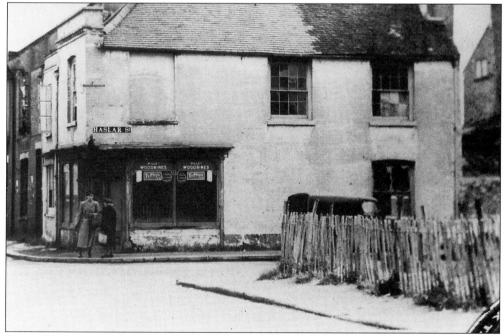

Two old ladies pause to gossip on the corner of South Street and Haslar Street 1950.

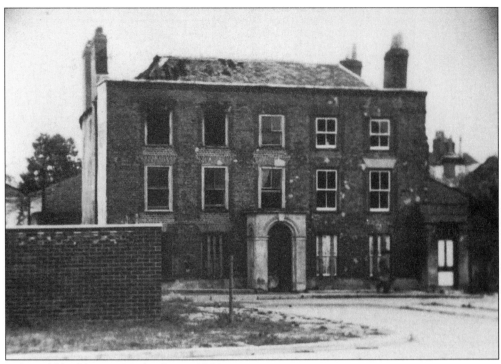

A fine old building on Haslar Street 1950.

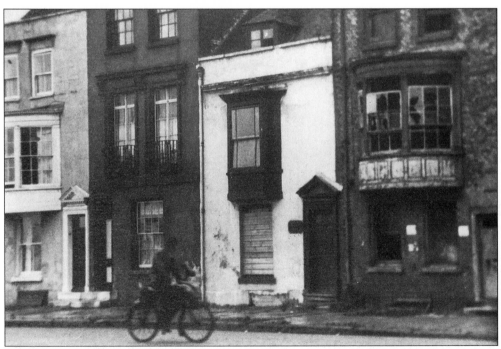

Clarence Square 1950. This was probably one of the most architecturally distinguished parts of the town with fine old building overlooking the harbour.

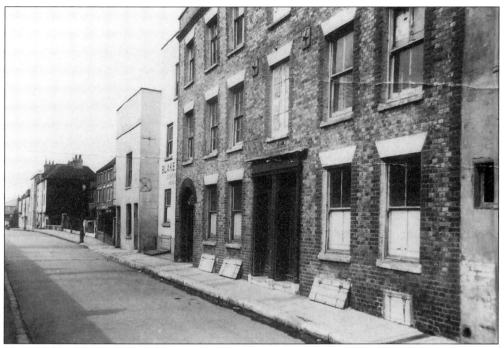

These old buildings of Chapel Row once overlooked Holy Trinity Church 1950.

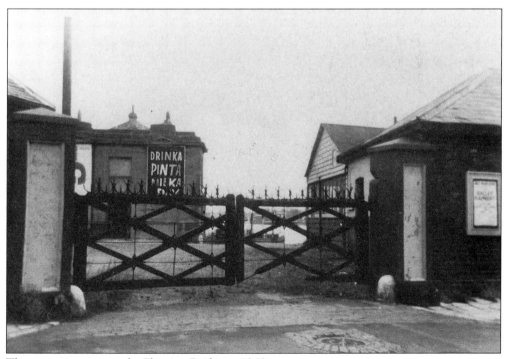

The entrance gates to the Floating Bridge *c*. 1960.

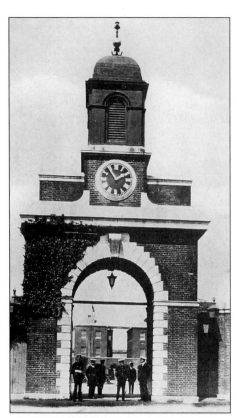

The main entrance of HMS *St Vincent*, Forton Barracks *c*. 1930. Forton Barracks, built in 1847, was the home for the Royal Marine Light Infantry and later used by the Royal Navy and renamed HMS *St Vincent*.

Most of the original barrack buildings have now been demolished although the fine frontage to Forton Road remains intact. New buildings have been erected in the parade ground for the college which now occupies the site. The fine iron and glass canopy to the wardroom was saved and is now at the entrance to the wardroom at HMS *Collingwood* in Fareham.

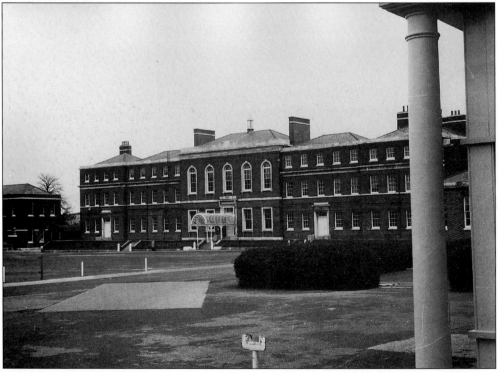

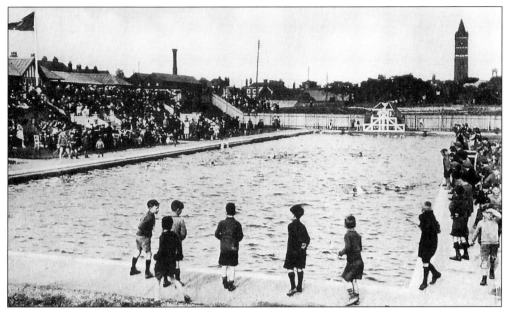

Gosport Swimming Pool *c*. 1930. Located near the model yacht lake, the outdoor pool was 220 feet long by 57 feet wide, filled with filtered and chlorinated seawater.

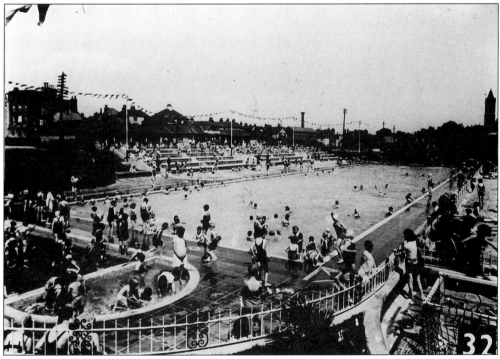

Gosport Swimming Pool *c*. 1950. On a hot sunny day, the swimming pool and the children's paddling pool were very popular with local people. The pool was backfilled and the site levelled in the 1970s.

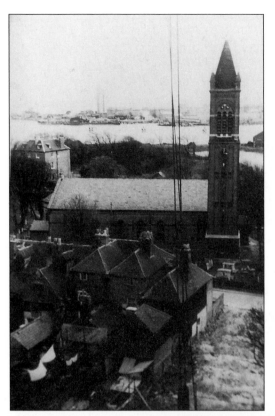

Holy Trinity Church seen from the top of one of the new tower blocks *c.* 1960. With the exception of the Church and the rectory all the remaining old buildings were demolished as part of the redevelopment of the area.

Holy Trinity churchyard, Haslar Bridge, known locally as 'Pneumonia Bridge', and Haslar beyond *c.* 1960. The new flats are under construction, the old gravestones are still in the church yard and the old Haslar Bridge has been replaced the temporary footbridge built after the former one had its centre sections removed during the Second World War.

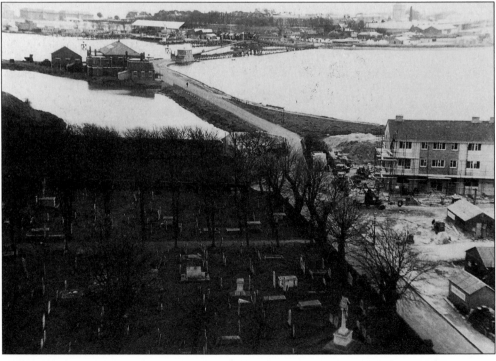

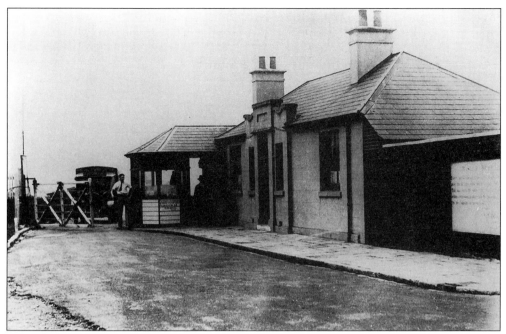

An ambulance from Haslar Hospital passes the old Haslar Bridge Toll House *c*. 1920.

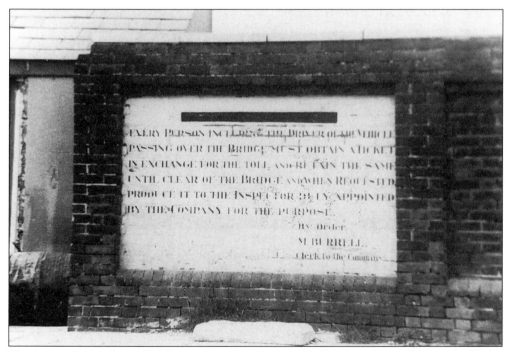

The sign put up at the end of the nineteenth century, when M. Burrell was Clerk to the Haslar Bridge Company, reminds drivers of vehicles that they must buy a ticket and keep to show to an inspector if required when crossing the Haslar Bridge.

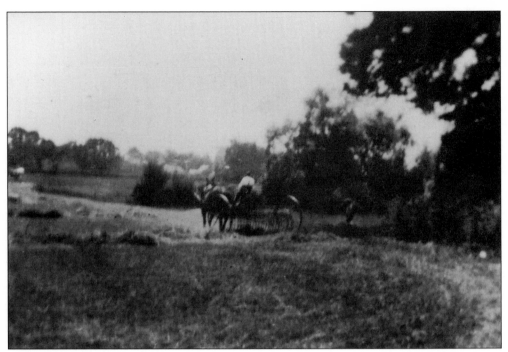

A horse-drawn hayrake 1929. It will be hard for many people to believe that this rural scene was taken at Elson.

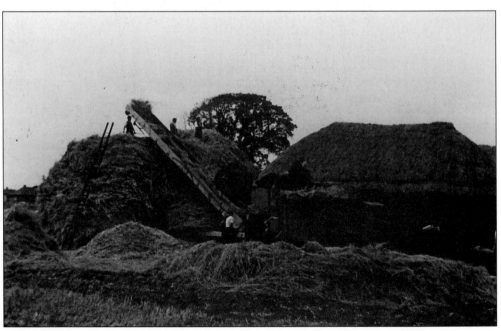

A threshing machine and straw elevator at work at House's Farm, Privett *c*. 1950.

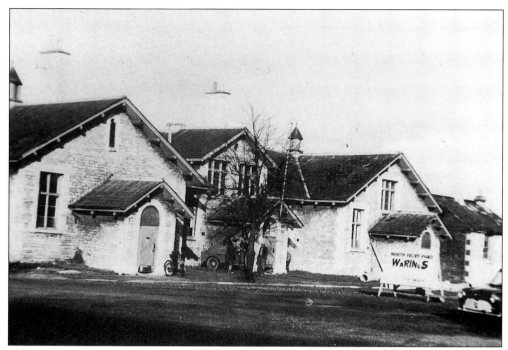

St Matthew's School, St Matthew's Square prior to its destruction *c.* 1962. The school built in 1844 stood next to St Matthew's Church and only survived demolition a few years longer than the church.

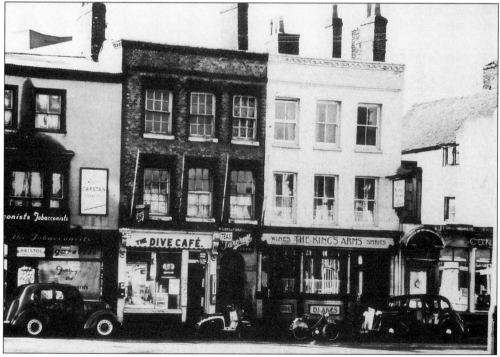

High Street *c.* 1959. The Dive Cafe was at this time located next to the King's Arms. In between was the entrance to Parcraft, the Harris and Parkin clothing factory.

Acknowledgements

To Dave Kemp, Assistant Curator of Gosport Museum for his invaluable assistance in checking the manuscript and for his first hand knowledge of the places and events depicted in this book during the last fifty years. With thanks to Alastair Penfold of Hampshire County Council Museums Service for his ceaseless enthusiasm for making local history widely accessible to everyone.

All errors and omissions are the responsibility of the author.

The former town library (pictured below) is now the home of Gosport Museum. The museum collects and displays the history of the Borough of Gosport. The photographs in this new book have been selected from the many hundreds of photographs held in Gosport Museum. Grateful thanks must go to the many people who have so kindly given photographs to the museum and ensured their preservation. There is, unfortunately, insufficient space to acknowledge each donor. We are, of course, indebted to all the photographers who recorded these snapshots of former times, so that although the places have changed their images are preserved on negative and photographic prints for posterity. The work of professional photographers W C Harvey, J A Hewes and Eric Stewart are represented, however it is doubtless the photographs of J C Lawrence & Sons that appear most frequently in this book, along with the photographs taken by many unknown amateurs. Finally we must hope that today's photographers will continue to record on film the people and events that will provide a comprehensive photographic archive for tomorrow's historians.

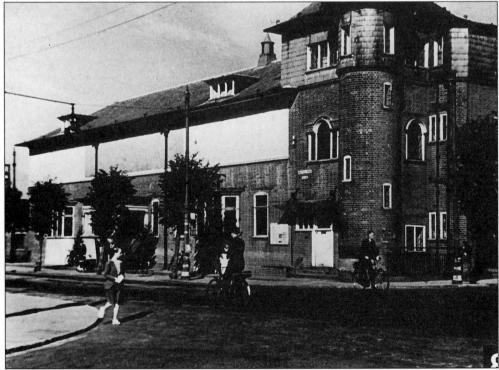

Gosport Public Library c. 1950. This purpose built library was opened in 1901 and closed in 1973 when the new library was built on the site of the Connaught Drill Hall.